COLWYN BAY
THROUGH TIME
Graham Roberts

AMBERLEY PUBLISHING

First published 2009
Reprinted 2010

Amberley Publishing Plc
Cirencester Road, Chalford,
Stroud, Gloucestershire, GL6 8PE

www.amberley-books.com

Copyright © Graham Roberts, 2009

The right of Graham Roberts to be identified as the
Author of this work has been asserted in accordance
with the Copyrights, Designs and Patents Act 1988.

ISBN 978 1 84868 677 9

British Library Cataloguing in Publication Data.
A catalogue record for this book is available from
the British Library.

Typeset in 9.5pt on 12pt Celeste.
Typesetting by Amberley Publishing.
Printed in the UK.

Introduction

Even at the start of the nineteenth century this part of the world, on the North Wales coast, was to a certain extent a medieval society where people made their own clothes, grew their own food, followed the seasons and operated according to traditions developed over hundreds of years.

The development of Colwyn Bay was the consequence of one man's death. Sir David Erskine, who lived at Pwllycrochan, died in 1842 at the age of forty-eight. He owned the majority of the land on which Colwyn Bay now stands, and for twenty-three years after his death his widow and son carried on managing the land. In 1865 they could manage no longer and the Pwllycrochan Estate was offered for sale, and the land which had been farm fields crossed by a turnpike road became, within thirty years, a new town recognised as an Urban District.

The Romans tramped across this area of Great Britain, the railway arrived in 1844 and after Lady Erskine sold the land wealthy people began to arrive from Lancashire and Yorkshire and families started to come for their holidays; Colwyn Bay began to thrive. Colwyn Bay is, therefore, in essence, a community formed in the Victorian era.

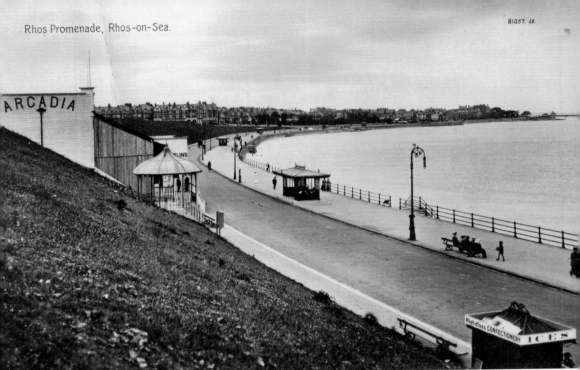

The Cayley Promenade
The promenade was opened in 1897 not only to provide a magnificent walk and roadway but also to act as a defence against the sea. In the 1920s Mr Catlin produced open-air concerts from his wooden and windy stage, which has long since disappeared. Each year on May Day we now have a fair on this stretch of promenade as seen in the picture below.

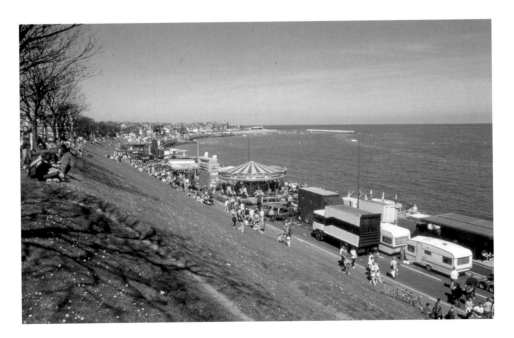

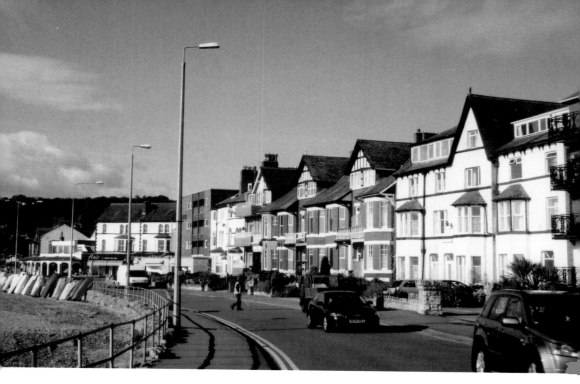

The Lodging Houses

In the 1860s a local man known as 'Old Price' wrote about these buildings, 'Along this expanse of turf at Rhos one has thought fit to erect a set of lodging houses and a hotel, in which the spirit and letter of ugliness are carried out but too faithfully by an architect who, if his own handiwork be not the death of him, will surely live to see them pulled down as a nuisance.' Of course, they are still there!

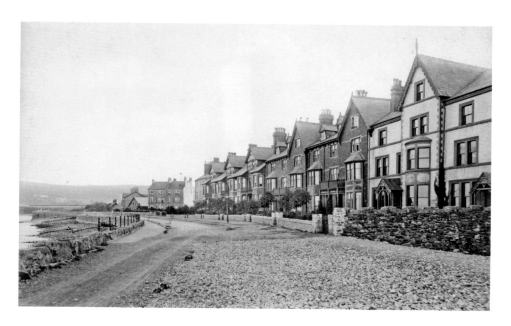

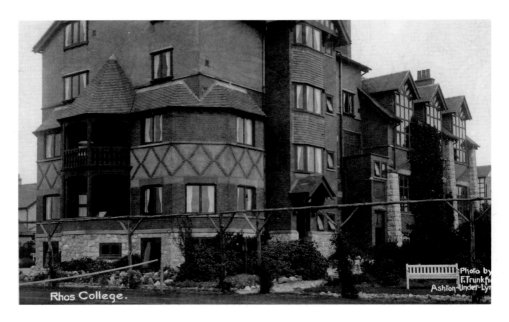

Rhos College.

Photo by
F.Trunkf
Ashton-Under-Lyn

St Mary's College, Abbey Road

In 1908 this was Rhos prep. school for pupils between seven and fourteen years of age. It closed in 1922 and reopened as a Church of England prep. school with the Revd Mr Langstaff as the headmaster. In 1948 the school passed to the Oblates Fathers of Mary Immaculate and was named St Mary's College, which duly closed in July 1992. Wainhomes demolished the building and built The Cloisters housing estate. It took the Oblate community forty years to establish the college; it took the demolition men four weeks to reduce it to rubble.

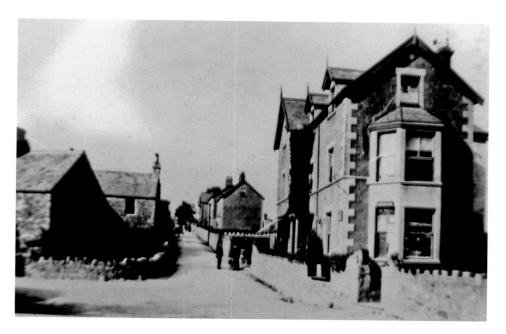

Rhos Road

Originally this road was a narrow hedge-fringed lane leading from Llys Euryn (page 8), down to the seashore where there was a small harbour; it was also the line taken by a small railway that carried the rock from Bryn Euryn quarry to the shore. There are still cottages on the road with the date 1883 inscribed on the walls, and it is now a busy thoroughfare packed with a variety of shops.

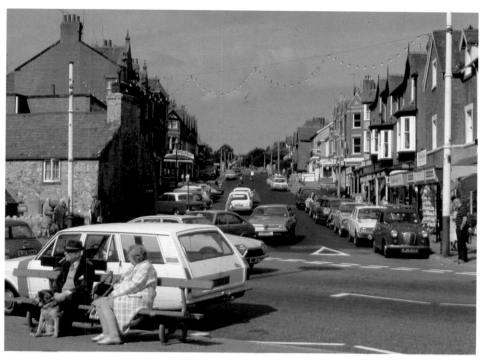

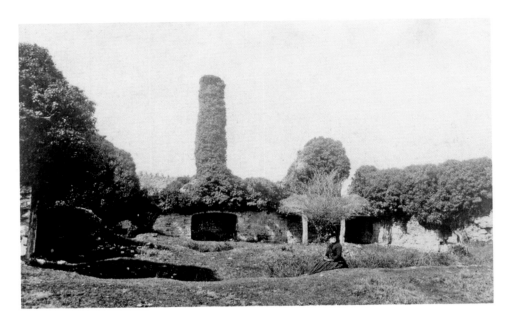

Llys Euryn

This is the spot on the lower slopes of Bryn Euryn where Ednyfed Fychan, the chief minister to Llewelyn the Great, built his home in the thirteenth century. The present ruin is all that remains of a house built for Robin — the eldest son of Gruffyd Goch, the leader of one of the old tribal divisions of Wales — in the fifteenth century. In 2005 grants were made available and the ruined rooms were marked out, the vegetation cleared and an information board erected.

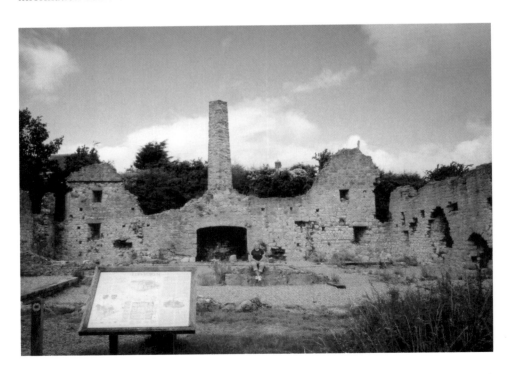

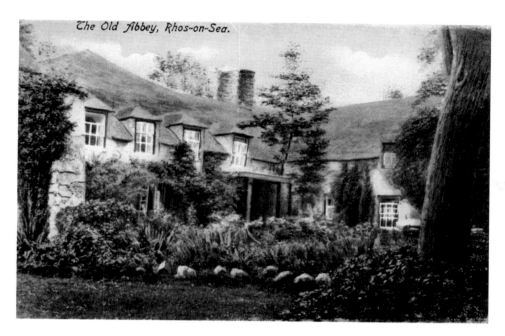

The Old Abbey, Rhos-on-Sea.

Rhos Fynach

Ednyfed Fychan (page 8) bought the land of Rhos Fynach in May 1230 but there may have been a building inhabited by monks on this spot before this date. In the 1950s and 1960s it was used as a café gaining business by being beside the swimming pool (page 13). After extensive rebuilding in the late 1970s it is now a pub and restaurant.

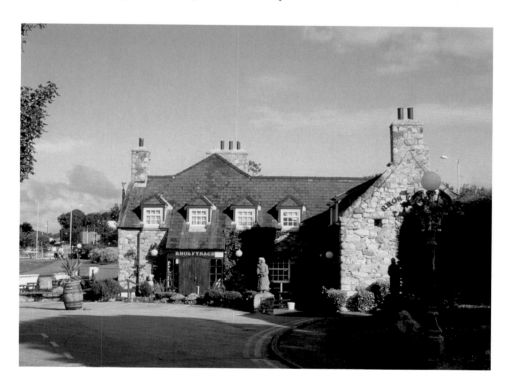

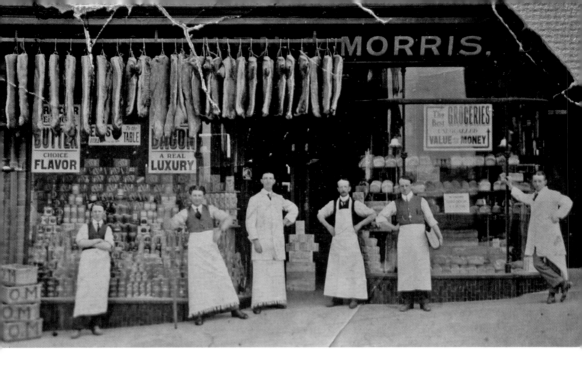

Owen & Morris, Grocers

The shop is on Rhos Road and Options dress shop now occupies the site. In the early 1900s the grocers provided provisions for all the large boats that called into Rhos-on-Sea. All the men in the picture above enlisted in the forces at the start of the First World War leaving the oldest man behind, but he developed a fever so the business closed. The shape and design of the window has remained the same for 100 years.

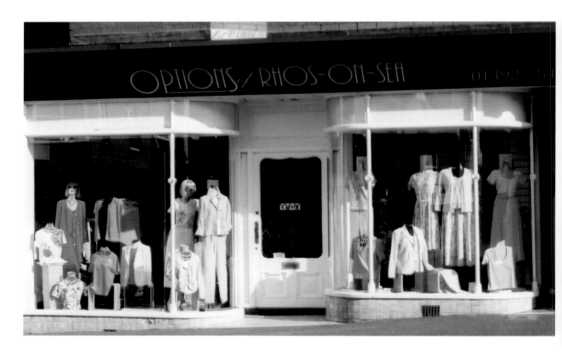

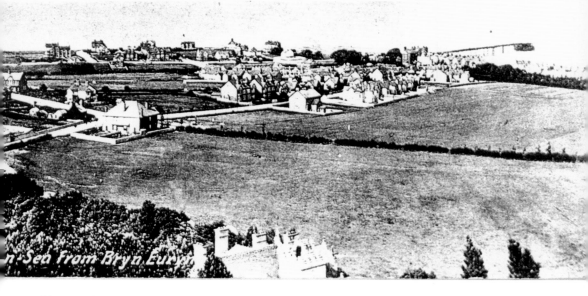

Rhos-on-Sea

Rhos-on-Sea is probably the oldest inhabited part of Colwyn Bay. Ednyfed Fychan built his home here in the thirteenth century and there was a fishing weir here at the same time; Roman coins have been discovered in the area and Capel Trillo on the beach was built in the sixth century. It is now a thriving community with five churches, four pubs, restaurants, many shops and very little land left for development.

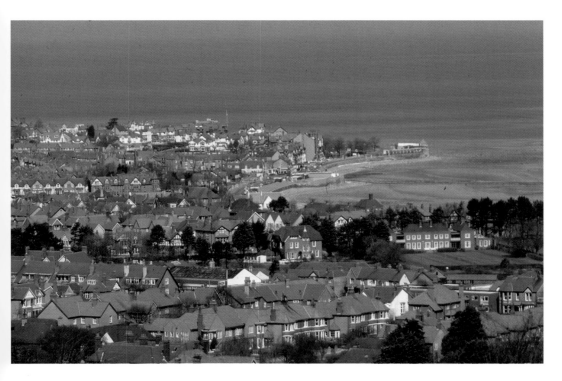

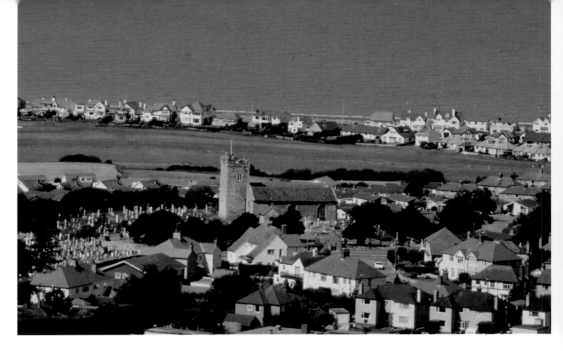

Llandrillo-yn-Rhos Parish Church

The earliest part of the church was built in the thirteenth century and the font is considered to be Norman. One of the bodies buried in the cemetery is that of Harold Lowe, the Fifth Officer on the *Titanic* who, after the sinking, went back with the lifeboats to try and save as many people as possible from the icy water. The church is now totally surrounded by houses and very busy roads.

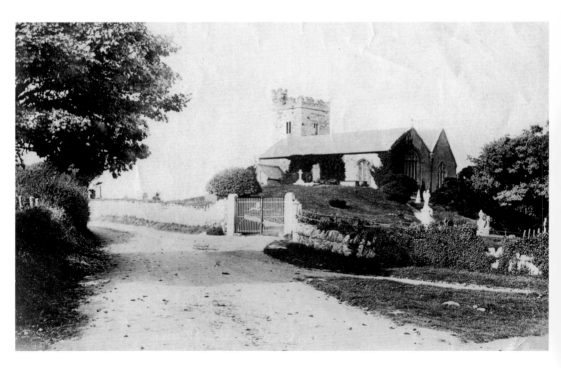

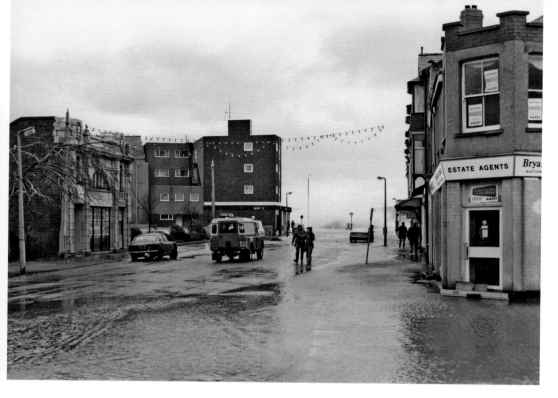

Tramway Avenue, Rhos-on-Sea

Penrhyn Avenue was originally known as Tramway Avenue because the tramway company bought the land in 1907 to lay the track from Penrhyn Bay to Rhos-on-Sea. The Picture Playhouse Cinema on the left in the picture above is now the Co-op shop; it seated 500 people and the advert boasted that 'every seat faces the screen'. Now that the breakwater has been built the road no longer floods in the winter.

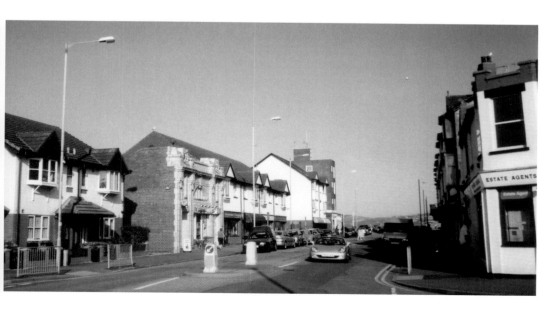

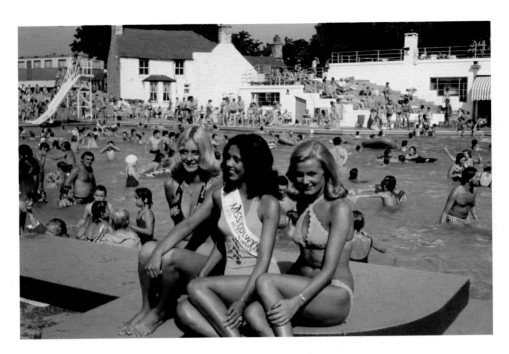

The Bay of Colwyn Sunbathing and Swimming Pool

The open-air swimming pool was opened in Rhos-on-Sea, behind the Rhos Abbey Hotel, on 28 July 1933. The first dive into the pool was taken by Jack Peterson, the heavyweight boxing champion of Great Britain. The adult bathers were charged 9d. It was a very popular venue where Mr Breeze, the pool manager, ran everything properly. It closed in the 1970s when an indoor pool was built in Colwyn Bay, and the area is now a park and garden.

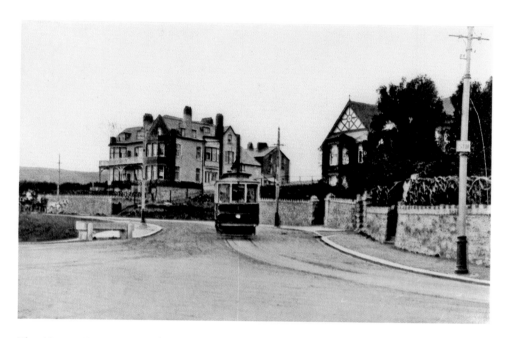

The Mount Stewart Hotel
The hotel is on the left and Crumpsall Grange (built by a man from that area of Manchester) is on the right, while the tram trundles down to the promenade. Between the hotel and Crumpsall Grange are now the Whitehall and Plas Rhos hotels and a private residence. The horse trough at the junction of the roads bears the inscription 'Metropolitan Drinking Fountain, National Trough Association' and is now full of flowers.

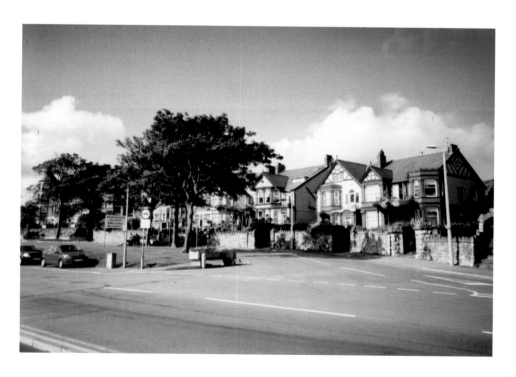

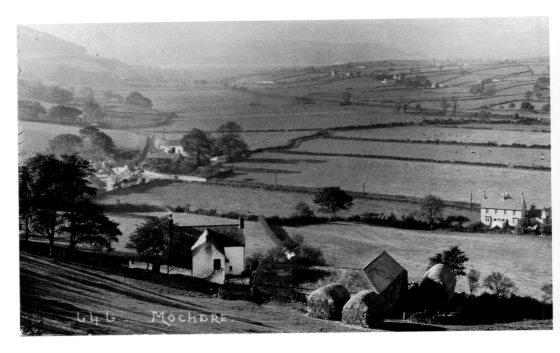

Mochdre

In 1900 the village was little more than five farms and a few houses. The farm in the bottom left-hand corner of the picture above is Tan Yr Allt Uchaf (High Farm). It is now a white-painted home on the corner of Beechmere Rise and Hazlewood Close and is seen smack in the middle of the picture below, just above the field. In 1880 the county's most famous criminal, John Jones, was hunted down to the Swan Inn following his escape from Ruthin Gaol.

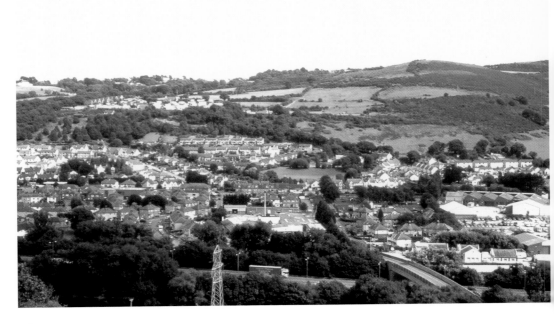

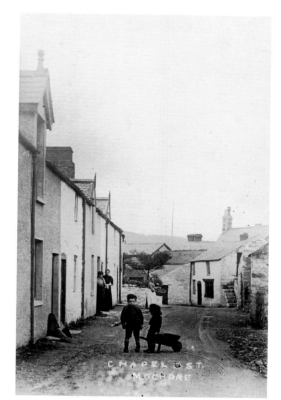

Tanrallt Street, Mochdre

This is the western end of the Old Highway, so named because it was the route taken by the horse-drawn coaches avoiding Sir David Erskine's land. It ran below the Pwllycrochan Woods and behind the town of Colwyn Bay. There was a smithy at the bottom of Tanrallt Street where a home still bears the name Smithy House. Other than this highway it is doubtful whether there was any other road worthy of the name in these parts much before 1750.

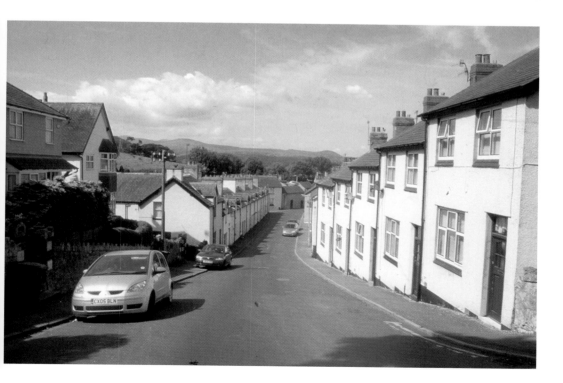

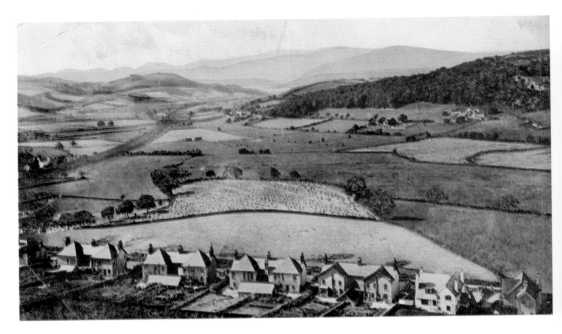

The Highways to and from Colwyn Bay

Above is the view from Bryn Euryn in 1920 and below in 2009 looking west along the roads leaving Colwyn Bay and leading to Conwy, Anglesey and Snowdonia. There are now three roads: Old Conway Road, which is a Roman improvement on an ancient Welsh track; the improved A5 of the 1920s; and the A55 dual carriageway, constructed in the early 1980s. The houses in the picture above are on Dinerth Road.

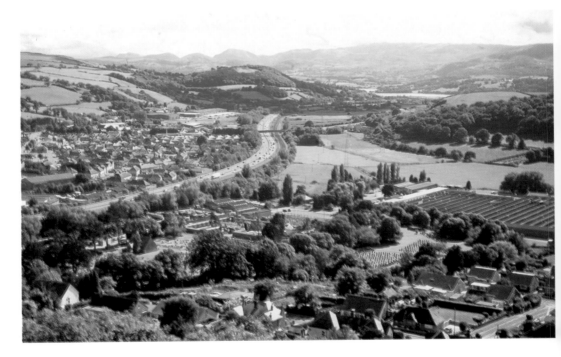

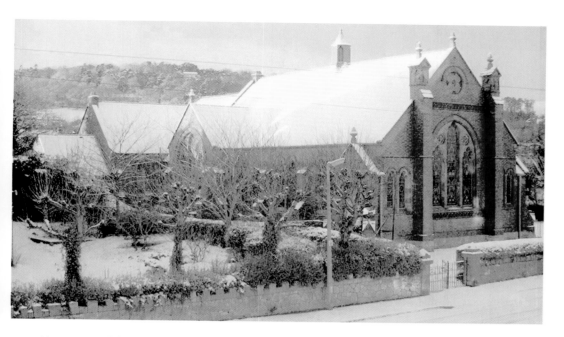

Hermon Welsh Presbyterian Chapel

The chapel above was built in 1905 at the cost of £4,136 6s 4d on land given to the Elders of the Church by Sir George Cayley. It was one of a group of four local Welsh Presbyterian churches. In 2008 the congregations of all these churches had fallen to such an extent that all the churches were closed; Hermon was demolished and a new chapel, Capel y Rhos (below), was built on the same site to accommodate all four congregations. It is on the corner of Llannerch Road East and Brompton Avenue.

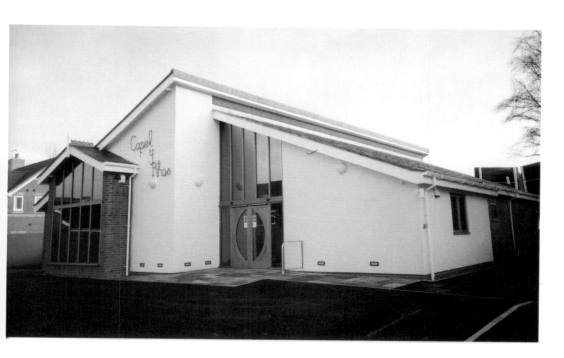

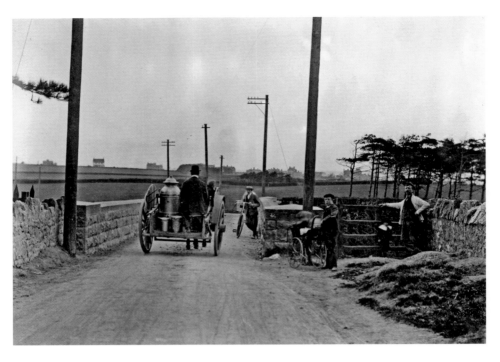

The West End Bridge

The present bridge in the picture below was built in 1985 as part of the A55 improvements and is ten feet to the east of the original bridge (above). The houses in the distance in the photograph above are on Rhos Road and the pine trees are where Hermon Chapel (page 19) was before demolition.

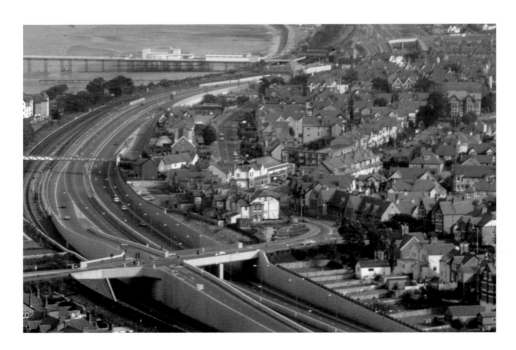

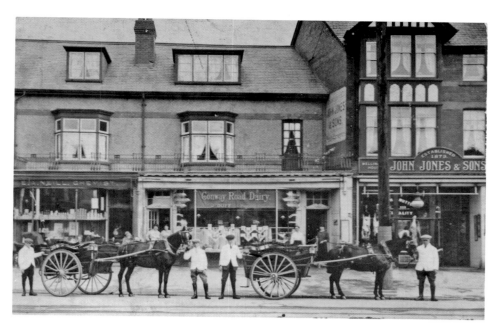

Duff's Dairy

In 1920 this stretch of Conway Road (140-146) in the West End of Colwyn Bay was a self-contained satellite of the main town. The three shops above were, from left to right, Ernest Alfred Neill the chemist, Jas. Duff the dairy and John Jones the butcher. Today they are Cohen's Chemist, the Godfather takeaway food service and Storm hairdressers. The carts in the picture were used for delivering the milk and the man second from the left, Sid Lawton, went on to start his own window cleaning business.

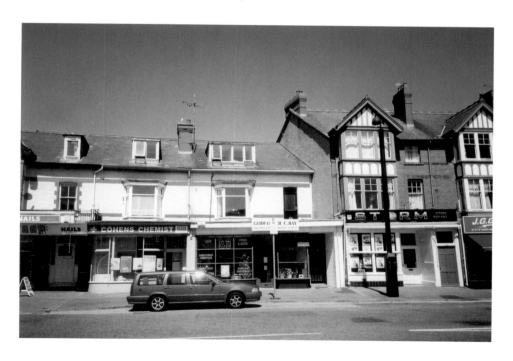

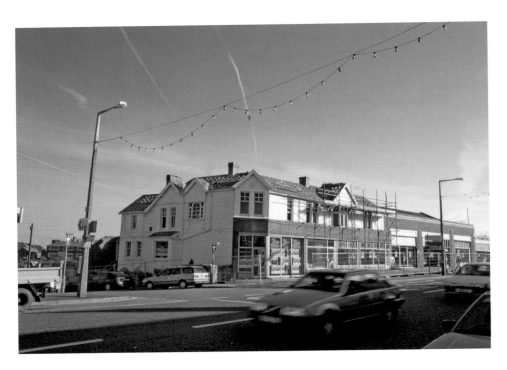

Francis Garage

In 1900 Mr Francis built this garage (above) in the West End on Conway Road (looking east in the photograph) as an extra garage two miles from his main one, next to the Central Pub in the middle of Colwyn Bay. In the 1960s the Ford Co. bought it and renamed it Gordon Ford's. It was demolished in 2001 and replaced by the Lidl store, which is looking west in the photograph below.

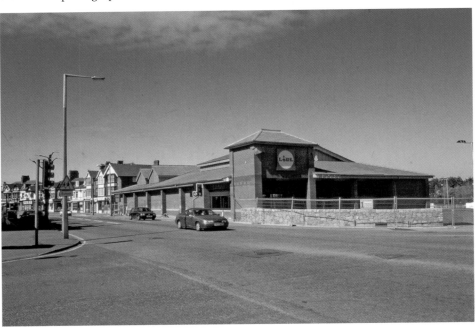

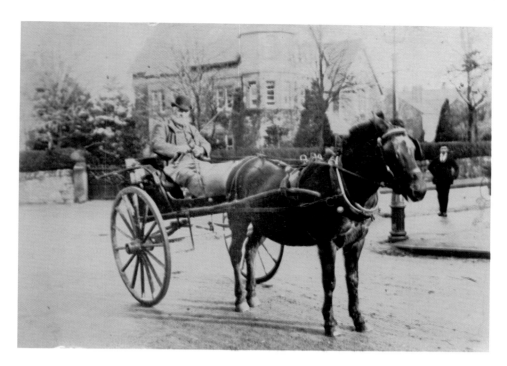

Mr Evans of the Mountain View

Mr Evans is pictured above in 1910 at the bottom of Pwllycrochan Avenue, with the Rhoslan building on the corner of Marine Road and Conway Road in the background. Rhoslan was the original gate house to Erskine House. Mr Evans was the publican of the Mountain View in Mochdre (below), an ancient hostelry on the ancient Old Highway leading to the town of Conwy.

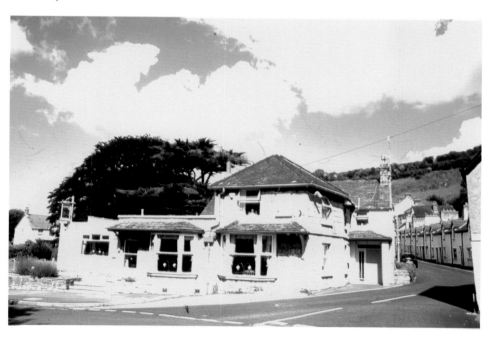

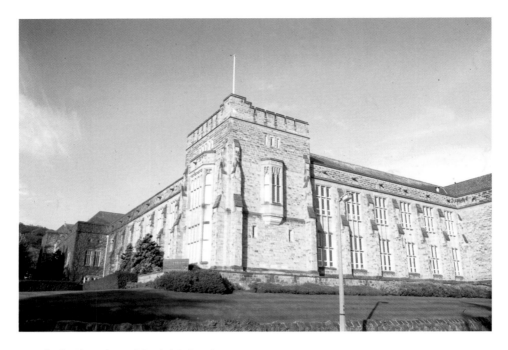

St John's Church and Rydal School

Revd Frederick Payne bought two parcels of land from the sale of the Pwllycrochan Estate, one for a church and manse, and one for himself on which to build his own home. The stone laying for the church took place in August 1882. In 1885 he sold the house he had built on the corner of Lansdowne Road and Pwllycrochan Avenue, called Rydal Mount, to Thomas Osborn who opened his private school for boys. Both the church and the school are still going strong.

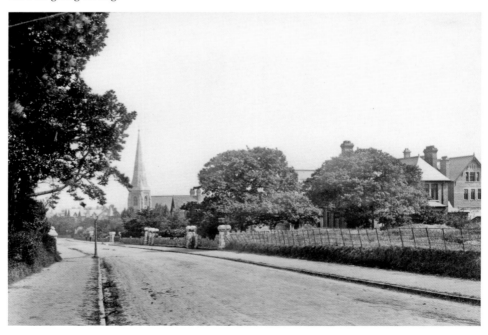

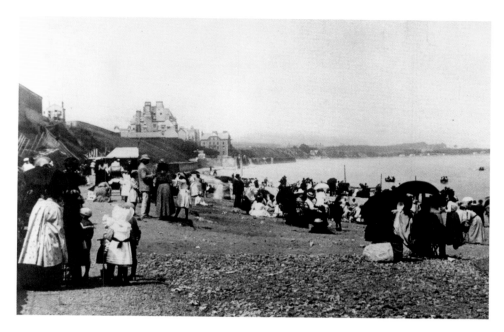

The Tourists

At the turn of the nineteenth century, Archdeacon Thomas, describing Colwyn Bay, wrote 'When I passed through in 1857 there was a solitary cottage and a toll bar, where there is now a flourishing seaside town'. In the 1960s people stared to look abroad for their holidays. Both pictures are taken from the site of the pier; the one above, before the pier was built, shows the Colwyn Bay Hotel, and the one below shows the Princess Court flats on the same site.

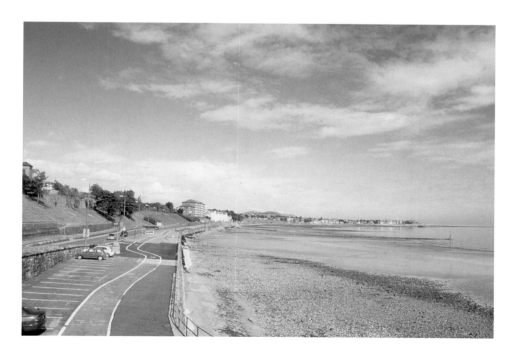

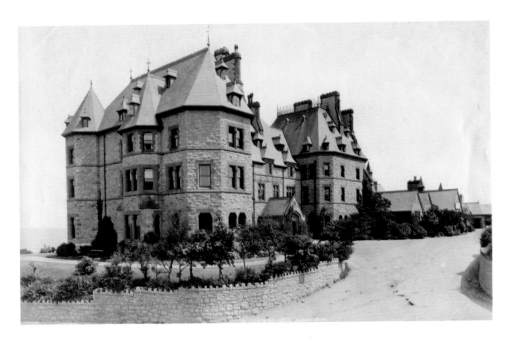

Colwyn Bay Hotel

Even though John Betjeman argued that the hotel should not be pulled down, it was still demolished in the early 1970s and replaced by Princess Court, a monumental slab of flats. The hotel was requisitioned during the Second World War by the Ministry of Food as their headquarters. Vic Groves and six colleagues had to vet the travelling claims of sundry inspectors of flour mills all over the country; their only help in checking the mileage claims was on old AA road book.

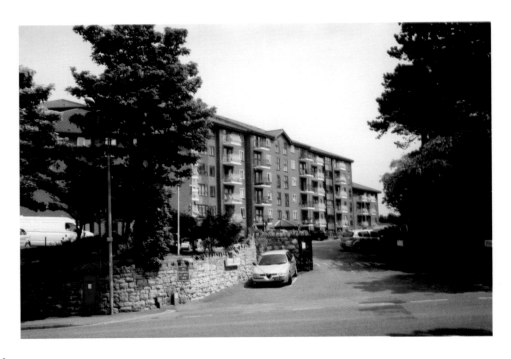

St Enoch's & Alveston Hotel

The hotel was on Marine Road opposite the Colwyn Bay Hotel. It advertised the situation as 'facing the sea, pure bracing air, delightful climate, charming scenery, water supply perfect,' adding, 'Terms moderate. Omnibus meets principal trains'. The hotel was demolished in 2008 and replaced with The Waterfront flats, the builder of which advertised the development with the line, 'launch yourself into a new life style'.

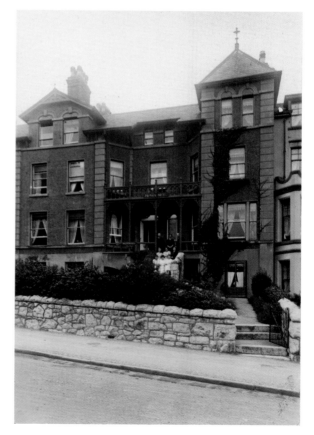

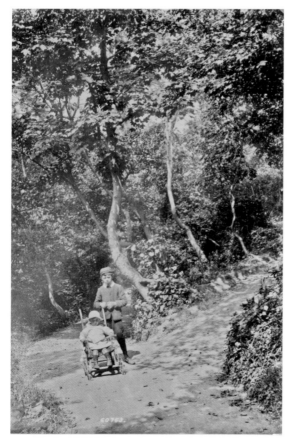

Pwllycrochan Woods

The woods form a spectacularly lovely backdrop to the town; they were bought by the Urban District Council on 31 October 1905 and were expanded eastwards towards the Nant-y-Glyn Valley with the purchase of the Sunnyside Estate on 22 September 1930. The woods are well managed by the local authority and afford the local people a place of beauty and tranquillity.

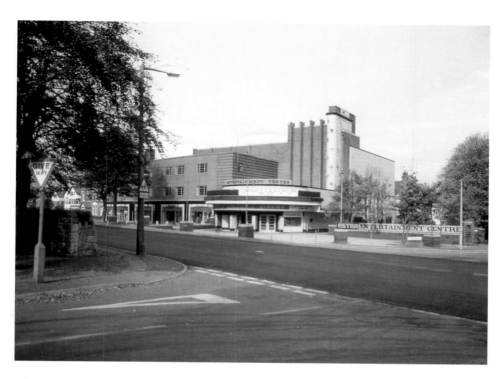

The Odeon Cinema

This was one of four cinemas in Colwyn Bay and was on the corner of Conway Road and Marine Road and was designed by Cecil Clavering, the designer of the Public Record Office at Kew. With the decline in cinema audiences it was demolished in the 1970s to make way for the Swn-y-Mor flats.

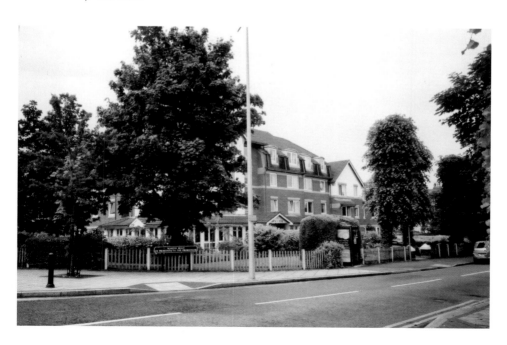

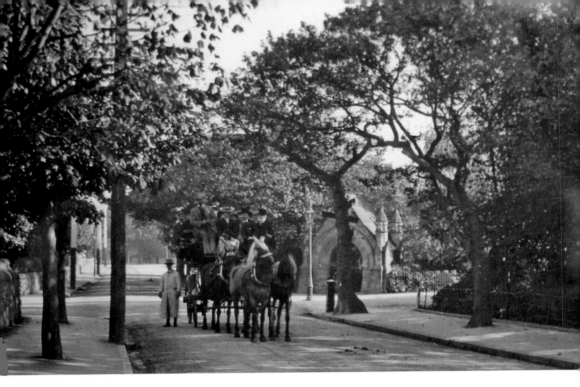

The Conway, Pwllycrochan, Marine Drive Crossroads

In the early 1900s this was the quiet road from Colwyn Bay to Conway. On the left were the two gate houses at the bottom of Sir David Erskine's driveway (now Pwllycrochan Avenue) which have been replaced with the Swn-y-Mor and Rhoslan flats. The archway on the right is the entrance to St John's Methodist church grounds; when the old photograph was taken there was no church, just the archway, as the church elders had run out of money.

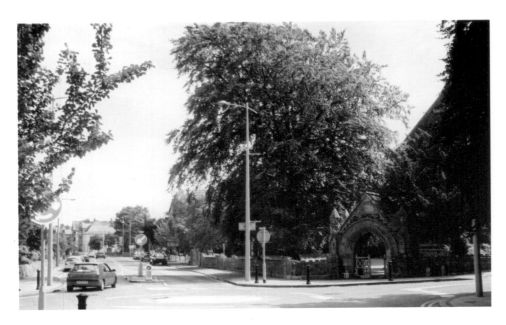

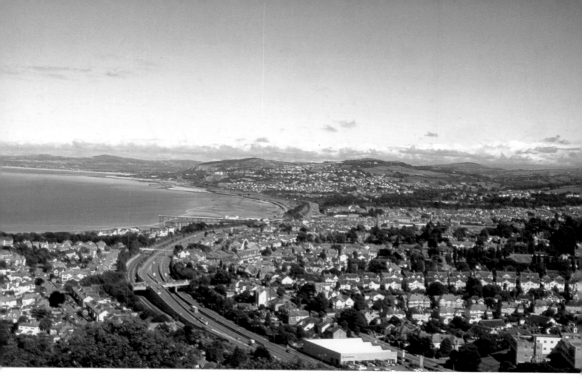

Colwyn Bay from Bryn Euryn
To the west (the left) is the ancient community of Llandrillo-yn-Rhos and in the distance to the east (the right) the original village of Colwyn. In between the two, Colwyn Bay was created to meet the demand for housing from wealthy people in England and to facilitate the needs of the hordes that descended for their seaside holidays. This was made possible by the arrival of the railway and by the sale of the Erskine Estate.

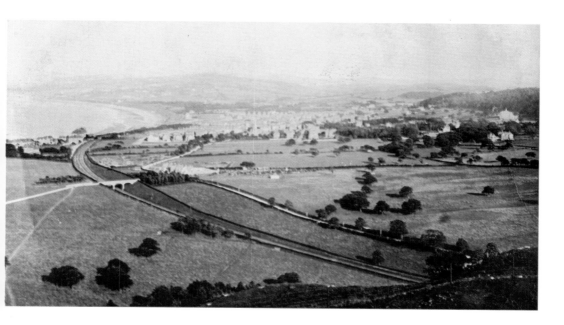

The Victoria Pier

The Pier and the first pavilion were opened on 1 June 1900. Madame Adelina Patti, known as the Queen of Song, sang at the opening ceremony. The first pavilion was burnt down in 1922, the second pavilion was burnt down in 1933 and the present pavilion is dowdy and now shut. For sixty years the pier and pavilion was the social centre of the town hosting concerts, plays, school speech days, civic dances, Round Table charity events and the like.

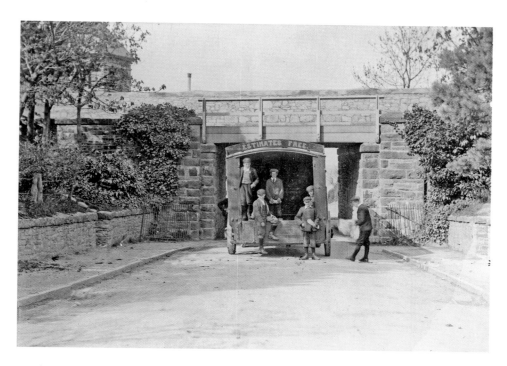

Marine Road Railway Bridge

Daniel Allen & Sons workmen having a rest in 1907, with the tower of the Alveston Hotel (page 27) at the top left-hand corner of the picture above. The surveyor's report of the same year reported, 'Motor car traffic in and through the district is greatly on the increase, and as many as 187 cars passed along the main road on August Bank Holiday last of which strong complaints are made by the public generally and especially by the shop-keepers.'

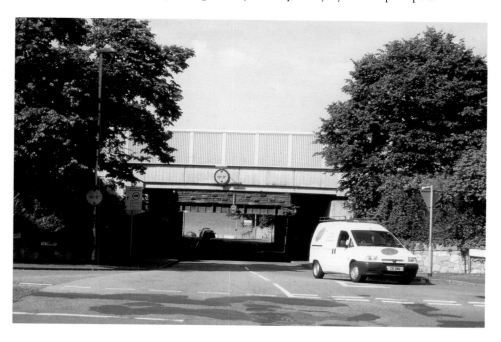

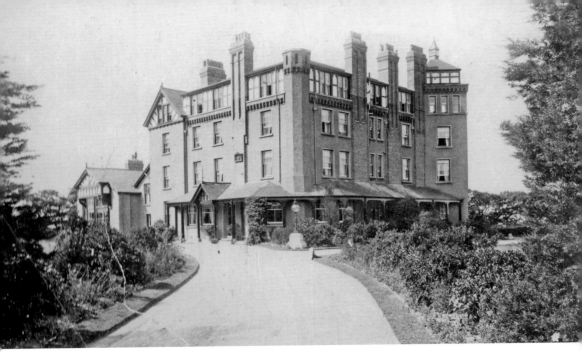

Hydropathical Hotel

It was at the end of the Upper Promenade and was taken over by Penrhos Girls' Boarding School in 1895. The school remained there until 1999 when the girls moved to join the Rydal School (page 24). This building was demolished in 2000 and an estate of houses and flats built on the site. During the Second World War, to make way for the Ministry of Food, Penrhos School moved to Chatsworth in Derbyshire, the home of the Duke of Devonshire. Thus it is that the main road running through the estate is called Chatsworth Avenue.

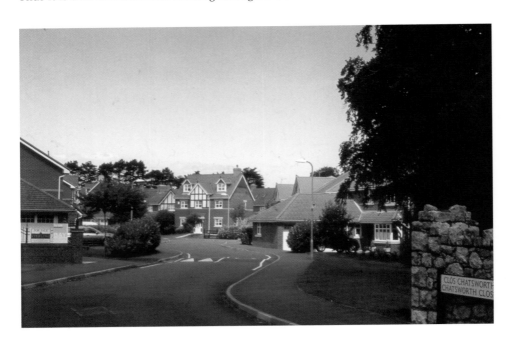

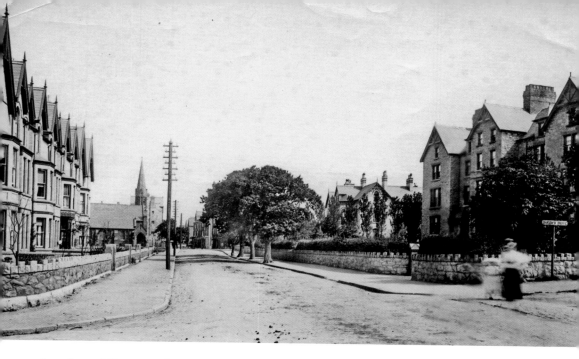

Junction of Mostyn, Abergele and Queen's Roads

Mostyn Road (page 66) runs off to the left, and Oaklands, the large building on the right, still displays the date 1888 on the wall and is now the address of Amphlett's solicitors. Next door was the town hall and war memorial. The spire on the left belongs to the English Presbyterian Church and the buildings on the left have always been known as the Refuge and Pearl Assurance Buildings.

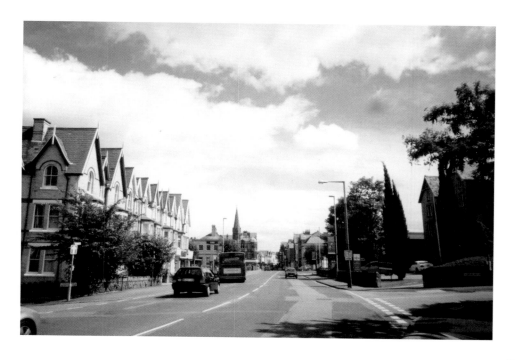

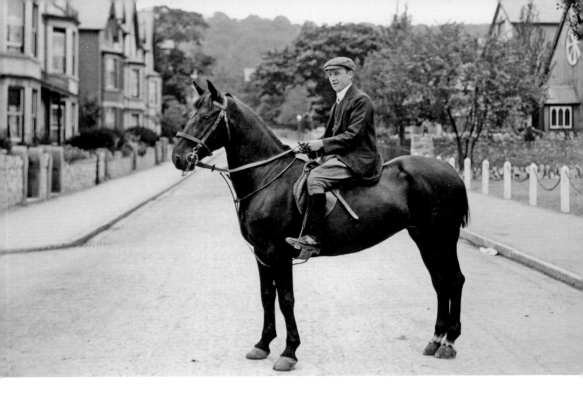

Coed Pella Road

To the right of Jack Jones (on his horse Eurgain) above, was the town hall but the building now houses the Department of Social Security and the Inland Revenue. In the 100 years between Mr Owen's time and that of Peggy Davies, seen leading her Red Cross team in the Civic Parade, the residential nature of the road has changed little. The tin church has gone as has the building which housed the Conservative Club, to be replaced by the Cwrt Bryn Coed flats.

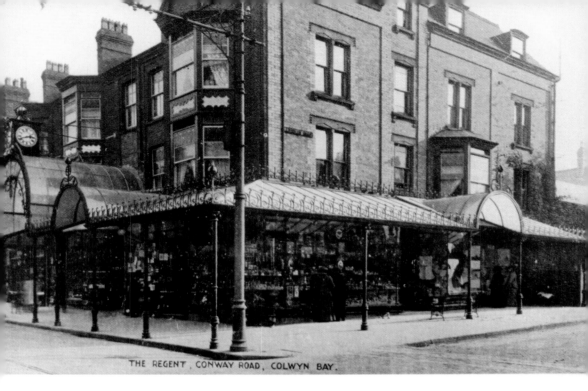

THE REGENT , CONWAY ROAD , COLWYN BAY .

The Regency

As an indication of the changing times, this building on the corner of Llewelyn Road was originally private apartments, in the 1920s it was transformed into The Regency fancy goods department store run by Mr John Homan; it was he who added the ornate veranda. Three years ago the building was pulled down and the present bland edifice was built which houses the local Probation Service.

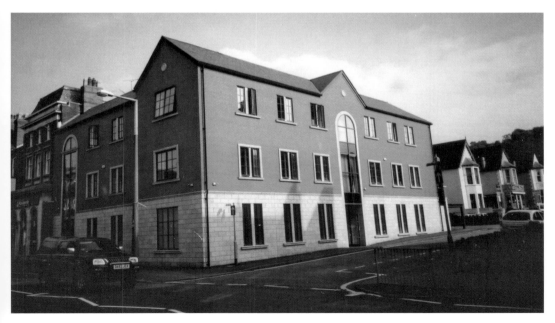

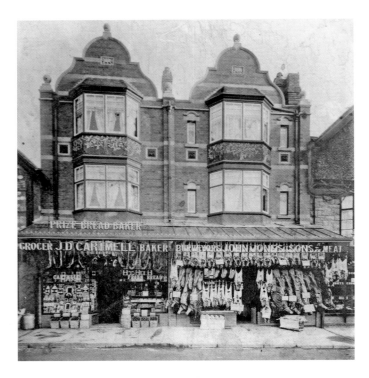

Cartmell the Baker and John Jones the Butcher

The building stands opposite St Paul's church at 21 and 23 Abergele Road and was built in 1873. The building to the right is the Royal pub. The baker's is now to let and the butcher's is used by the North Clwyd Animal Welfare charity. The change of use is a stark reminder of the influence on town centres everywhere of the ever increasing use of supermarkets.

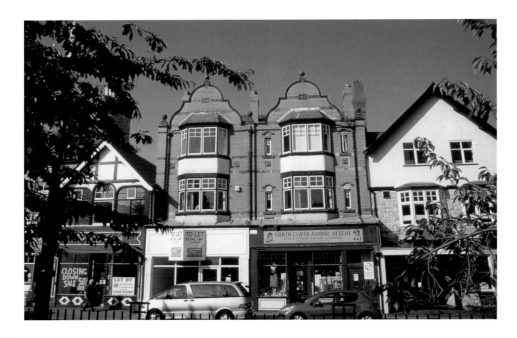

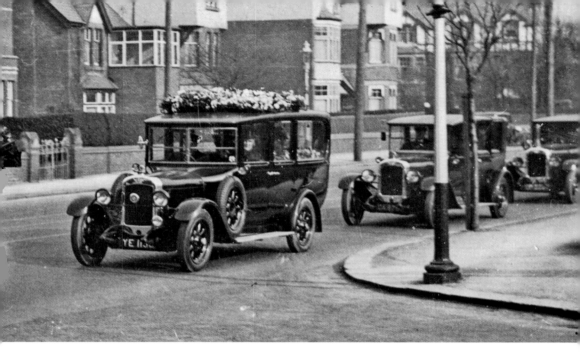

Baron Colwyn's Funeral

The funeral cortège is on Conway Road passing the interchange with Walshaw Avenue. The middle building in the background is now the Rysseldene Doctors' Surgery and the one on the right is used by the White Gables Dental Practice. The Rt Hon Baron Colwyn, PC, DL, lived at Queens Lodge, a lovely building which still exists; he was the mayor at the time of the Incorporation of the Borough in 1934 and he died on 26 January 1946.

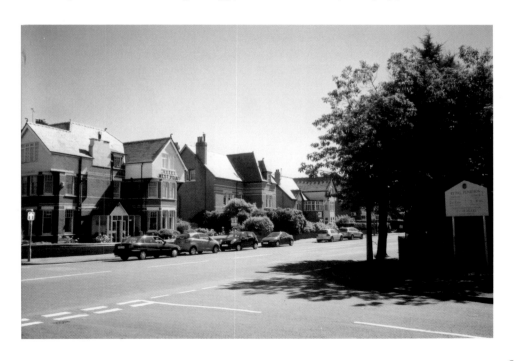

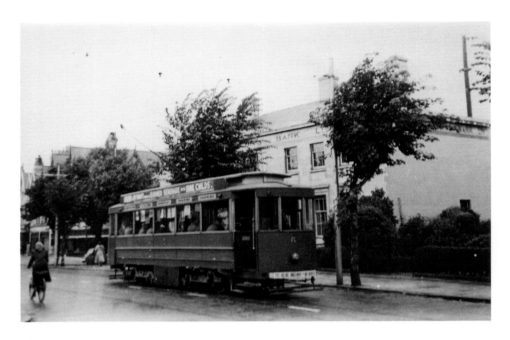

The Trams

A single-decker tram on Conway Road outside Williams Deacons Bank (now the Royal Bank of Scotland) in 1949. The tramway from Llandudno to Colwyn Bay was opened in October 1908 and extended to Old Colwyn in 1915 helping to accelerate the development of the district. The last tram ran on the evening of 24 March 1956, and every time work is carried out on the road today the workmen find the old tramlines buried beneath the tarmac.

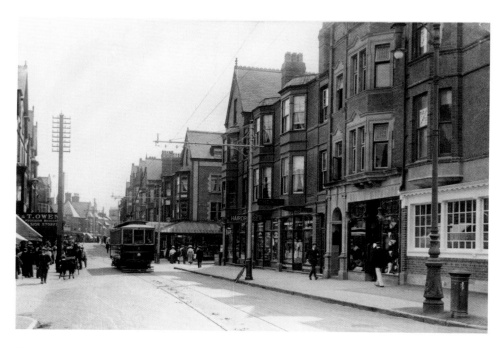

Conway Road

Looking east towards the centre of town with Llewelyn Road on the right. Today the building on the left-hand corner is Barclays Bank and the one on the right was the District Bank and is now used by a department of the local council. On the right of the old picture the building with the imposing doorway was the Estate Office, words that are still inscribed on a tablet on the wall. It was from there that Mr John Porter ran the affairs of his large Pwllycrochan Estate.

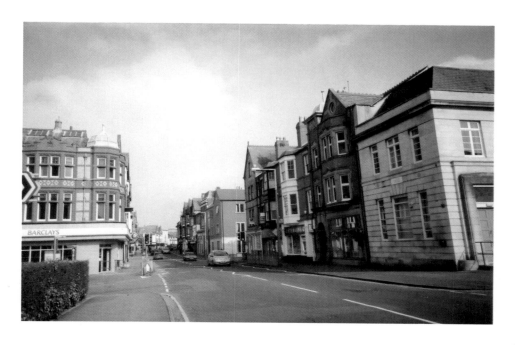

Home and Colonial Tea Stores
In ninety years this shop at 14 Abergele Road has been transformed from selling tea to unisex hairdressers, the FNVI Hair Studio. In 1920 there were nine members of staff and now there are two hairdressers. In the 1920s there were three shops next door to one another, one selling meat, one selling fish and one selling tea; only the butcher's remains.

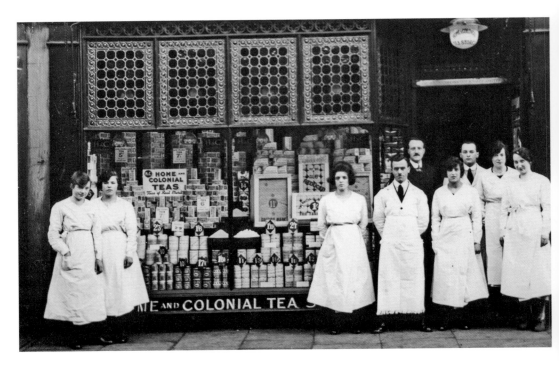

Arundale's Fishmongers

There have been five Arundale family fishmongers' shops in Colwyn Bay. This shop, at no. 16 Abergele Road, was run by Eric (now Clwyd Textiles furnishers shop). John ran the one opposite St Paul's church, Frank looked after the one opposite Woolworths and James and his son Len were at 93 Abergele Road in the East End of Colwyn Bay. All these shops are now gone, but Philip, John's son, keeps the family business going in Station Road.

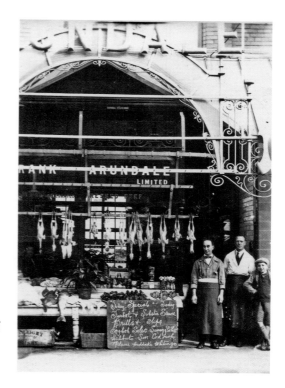

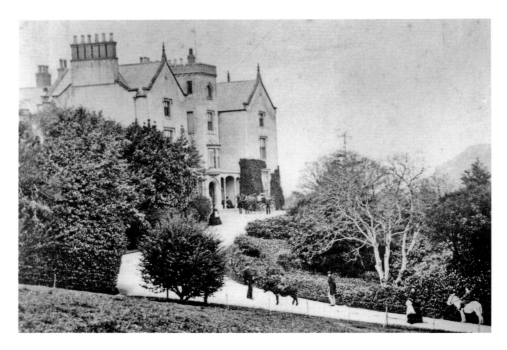

Erskine House, Pwllycrochan Hotel, Rydal Preparatory School

This was the home of Sir David and Lady Erskine until September 1865 when the estate was sold. The house, gardens and farm buildings were bought by Sir John Pender for £26,000. A few years later John Porter, JP, turned it into a hotel, and during the Second World War it was requisitioned by the Ministry of Food. In 1953 Rydal prep. school took over the premises and it remains a school to this day.

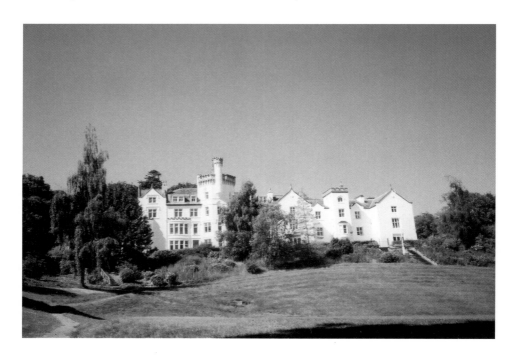

S. K. Williams Ltd and Clock House

S. K. Williams was an off-licence run from 57 Abergele Road and known locally as Clock House because of the prominent clock hanging on the wall. The building was built many years before those on either side of it and is now the Cinnamon Lounge Bangladeshi restaurant. The man beside the car was Ben Bishop who was soon to serve as a soldier in the First World War, which he survived. His picture was taken on the corner of Marine Road and Princes Drive.

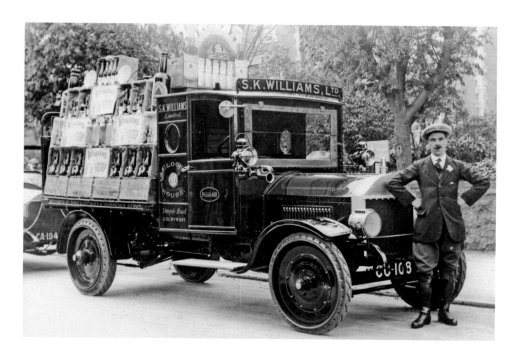

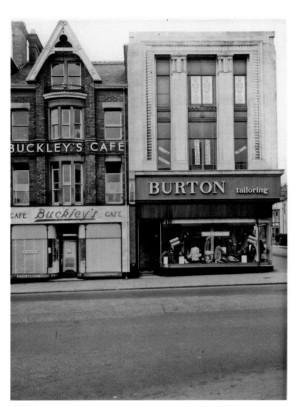

The Little Iron Shop

This shop, below, stood on the corner of Abergele Road and Woodland Road West opposite the Central pub. This is now where the Burton building is located which was built in 1928. Next door was Buckley's Café which was run by Dick Moore who when playing for Hampshire C.C. in 1937 scored a record 316 runs in 380 minutes. The café building is now the NatWest Bank and the Burton building is used by Hallmark Cards. The Little Iron Shop was erected in 1860 as an outpost of the Pwllycrochan Hotel to refresh the visitors.

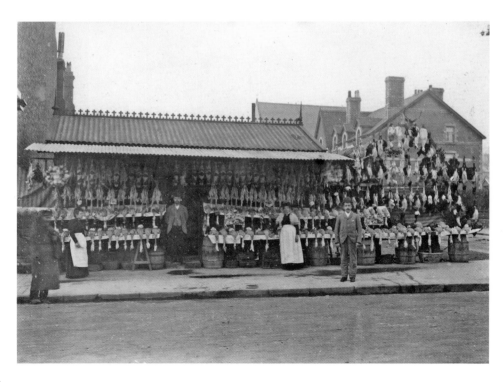

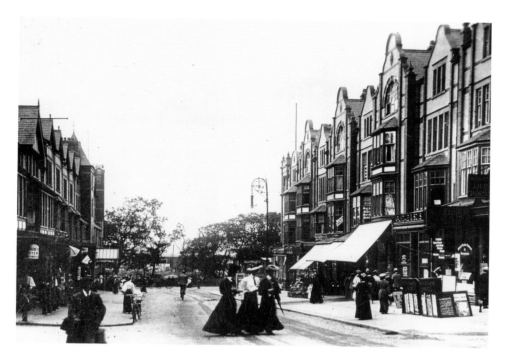

Penrhyn Road

For thirty years from the '30s to the '60s this was one of the busiest shopping roads in Colwyn Bay. At the bottom corner was the Metropole Hotel which has been transformed into flats. Alfred Hayley the photographer, George Rhodes the tobacconist, Emily Evans the milliner, Mills & Son the cabinet makers and Fleets the piano dealers were all in this road. It is now dominated by banking outlets of one sort or another and a recent survey suggested that this road is financially the most lucrative in the town for the collection of parking fines.

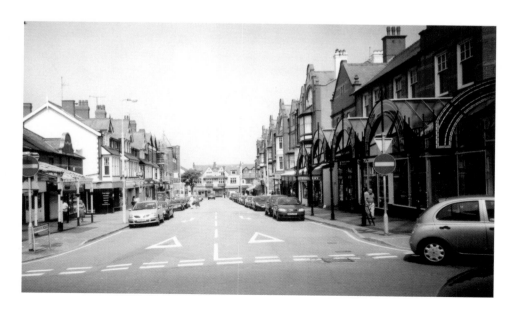

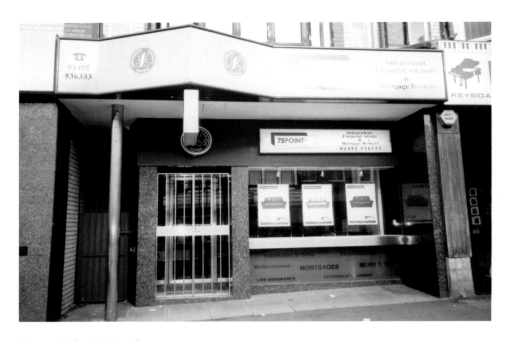

Gas and Electricity Showrooms

The premises at 14 Penrhyn Road are now owned by the 75 Point 3 Independent Financial Advisory business. John Vivian Chaplin (below) ran the electricity side of things and Dick Chaplin the gas side while Dolly Boardman (below) ruled the world in the shop and Harry Blythe kept a benevolent eye on everything.

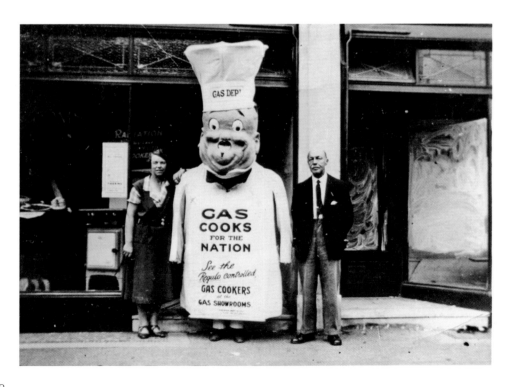

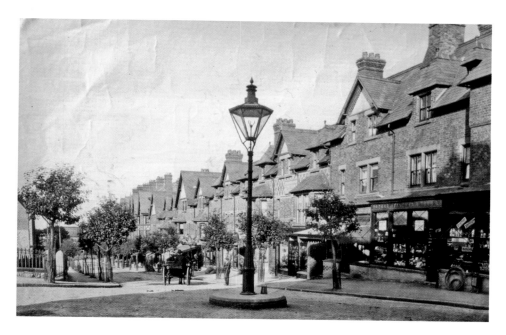

Station Road

From the 1930s to the 1950s people came from miles around to shop in this road. As well as Daniel Allen (page 50) and W. S. Wood's (page 51) Harry Pinnington ran the Cartmel Hotel, Frank Little had an excellent grocery store, Neville & Co. was an upmarket drapery shop, J. W. Lees & Co. sold wine and — a sign of the times — the Black Boy Chocolate Co. sold chocolate. The only surviving original trade is the W. S. Wood's store now run by Peacocks, also a retail store.

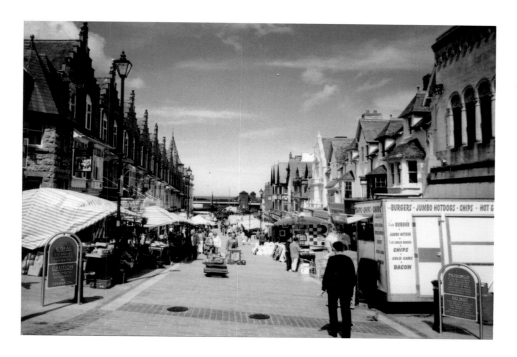

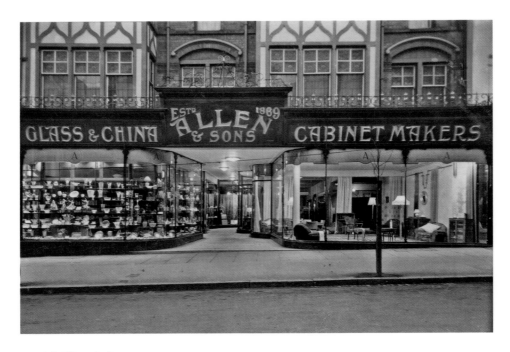

Daniel Allen & Son

Mr Allen arrived here from Leek in 1879 and opened his store in Station Road. He was one of the first English tradesmen to settle in the new Welsh resort. The shop, which dealt mainly in furniture of all sorts, closed in 1971 because — as Mr Allen's grandson, Edgar, said — 'poor workmanship was threatening the reputation of the business which had been built up over 100 years'. The premises are now home to a pub.

W. S. Wood's

Mr Wood and Mr Allen ran the two premier department stores in North Wales. William Stead Wood opened his store in the 1920s (above) and then employed his friend Sydney Colwyn Foulkes to design a new building (below) to replace the old one. They tore down the 1920s shop and slotted in the present imposing building (below, on right) which was opened in 1933. The façade of the building is clad with Portland Stone, an idea suggested by Mr Peake who ran the firm making the high quality Rodex Coats.

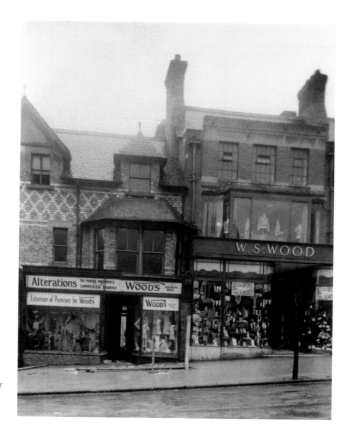

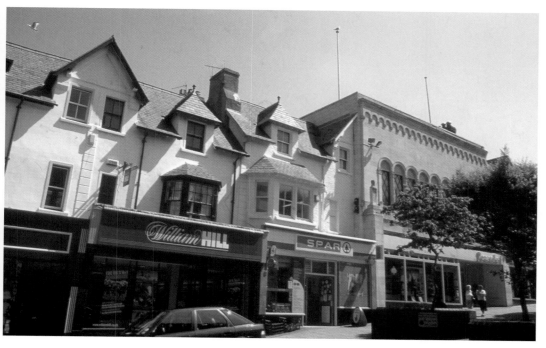

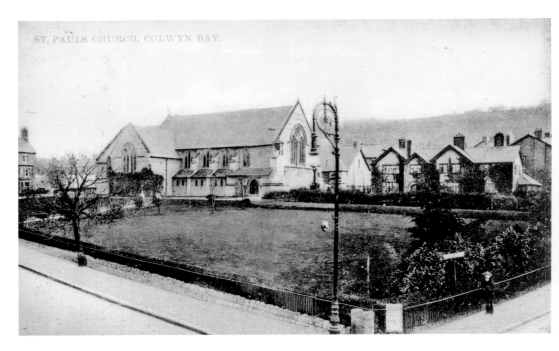

St Paul's Church

The first Church of England services in the town were held in 1871 in a carpenter's shop in Ivy Street. In 1880 an iron and timber building was built on the present site of the church which six years later was destroyed by fire. The present church was started in 1887 and six years later the new Parish of Colwyn Bay was created from the old Parish of Llandrillo-yn-Rhos. The tower was added in 1911 and in 1980, when the Revd Canon Trevor G. Davies was the incumbent, the whole church was refurbished.

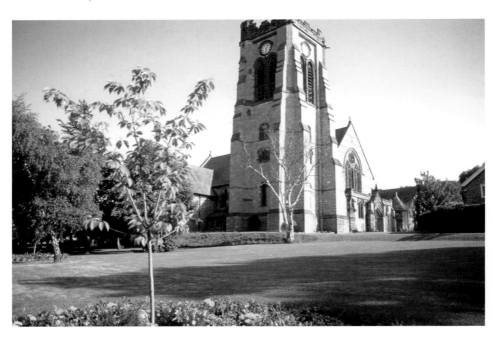

The Railway Station

The site of the station was chosen in 1847 in deference to Lady Erskine whose land on which it was built and on the stipulation that her carriage should always be accorded precedence. One hundred years later it was a busy place with four platforms servicing the needs of thousands of holiday makers. There are now two platforms. The old picture shows the former Station House in about 1850.

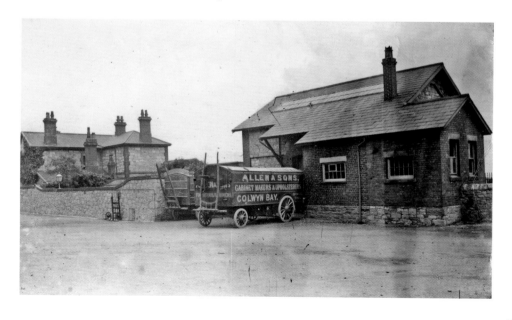

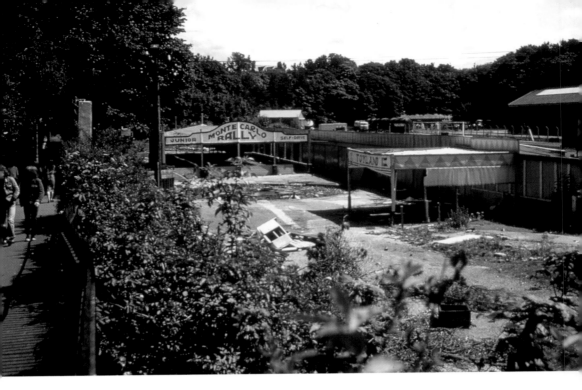

The End of Pat Collins' Amusement Park

The A55 now runs smack through the middle of where the amusement park once stood between Victoria Avenue and the railway goods yard. The top picture shows the park being dismantled in 1980 after giving the locals forty-five years of happiness. The gallopers on the carousel were the same ones used for the entire forty-five years. It is at the point that the A55 enters a tunnel below the station forecourt.

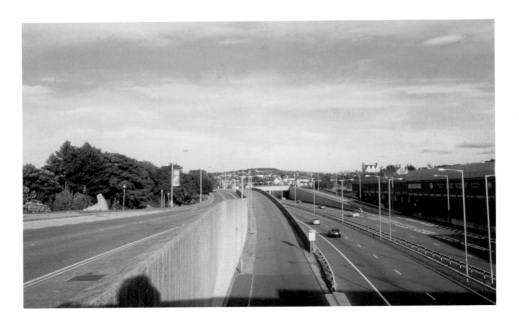

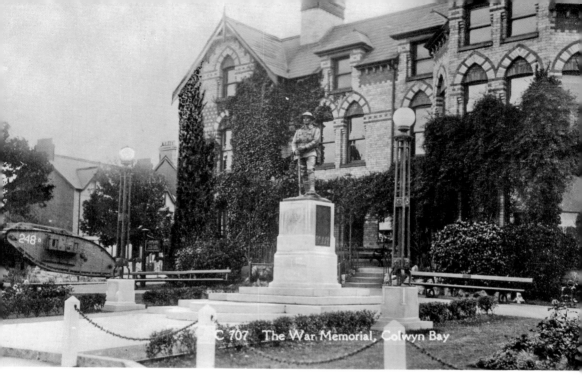

C 707 The War Memorial, Colwyn Bay

The War Memorial and Town Hall

The town hall (above) on the corner of Coed Pella Road and Conway Road was used from 1904 until 17 March 1964 when the council moved to the new Civic Centre in Glan-y-Don. The old building was then demolished and the war memorial was moved to Queens's Gardens (below). The cost of the memorial, £1000 in 1922, was met by subscription; Lord Colwyn gave £50, Dr Henry Morris Jones, JP, gave £5 5s and the Higginson family gave 5s.

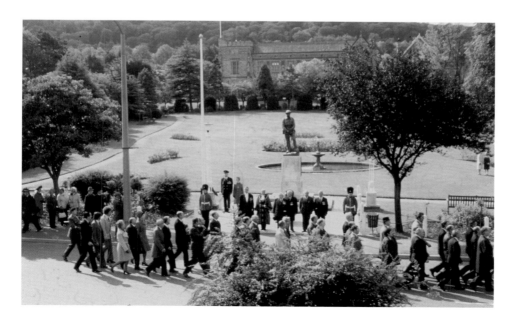

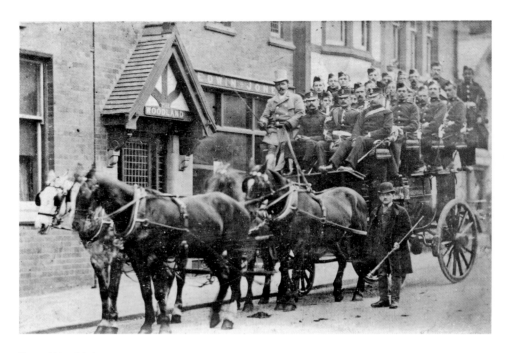

Boer War Veterans, 1910

The return of Colwyn Bay's Boer War volunteers (above) caused intense interest. The procession started at the Public Hall (now Theatre Colwyn, below) on Abergele Road, then used as the local Armoury. The picture shows them outside what is now Matthews' Hardware Stone. One of the volunteers was Sergeant A. Allen, who in 1900 wrote home from South Africa, 'We met a man in charge of an escort going down to Pieteermaritzburg gaol for two years. His crime was refusing to take a colour-sergeant his tea.'

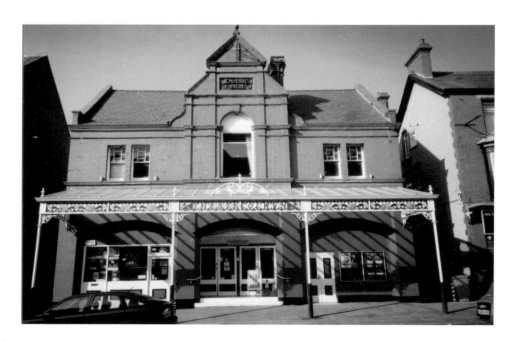

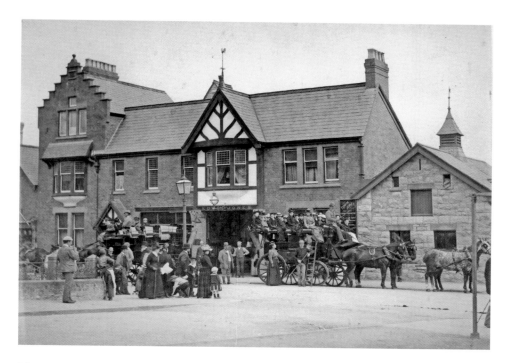

The Mews

The Mews, above, stood on Conway Road where today you see Matthews' hardware store (below left) which before that was the Cosy Cinema. In 1900 the property was owned by Mr Edwin Jones who operated the four-in-hand coaches which bore visitors to the beauty spots of the district. The fare for the round trip to Betws-y-Coed was 10s and the box seats were 2s extra.

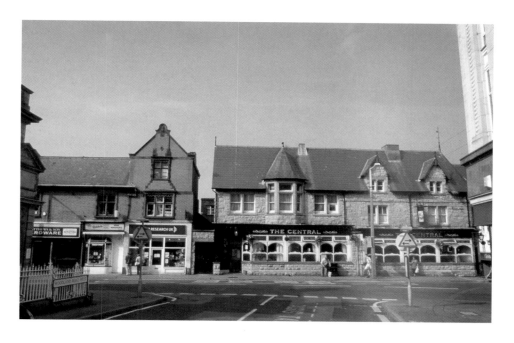

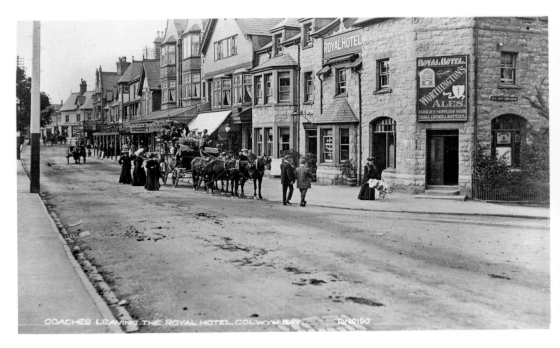

COACHES LEAVING THE ROYAL HOTEL, COLWYN BAY. DN2190

Abergele Road

This is the turnpike road seen above *c.* 1912. The road had been constructed a few years before Telford's survey of 1811 when the annual tolls amounted to £191 and when Telford described this road as 'The Present Mail Road'. The buildings in the pictures are some of the first to be built in the area as is demonstrated by their higgledy piggledy architecture and are all still in place today.

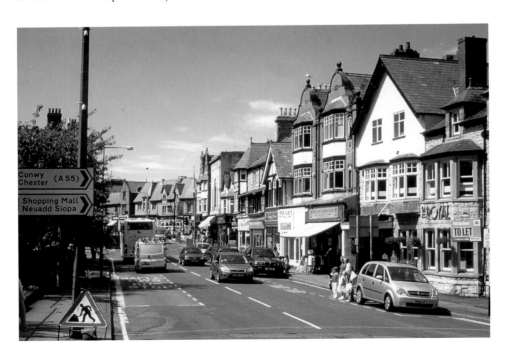

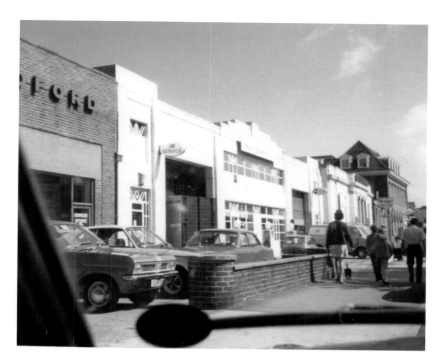

The Arcadia

Of the three buildings above on Prince's Drive, only the post office remains and that is empty awaiting a buyer. The garage, the Chester Engineering Co., and the cinema, the Arcadia, were demolished in the 1980s to make way for the dual carriage A55. The Arcadia was replaced by a new sorting office for the post office, and Barclays Business Centre and Thornley Leisure now have offices where the garage once stood.

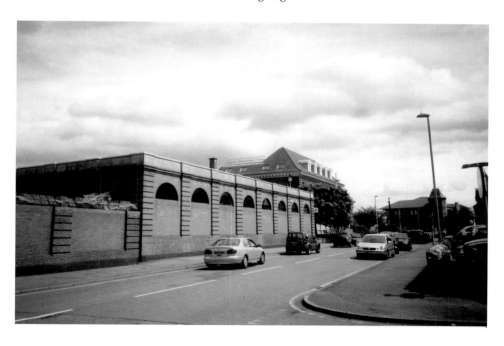

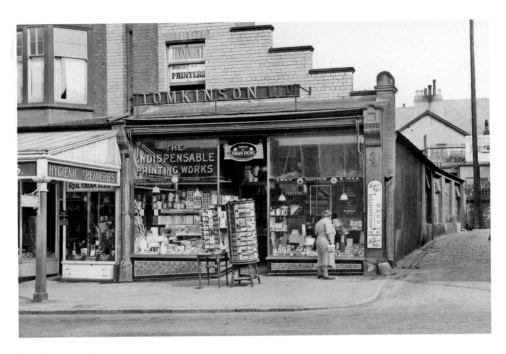

Tomkinsons's

This stationary shop on Penrhyn Road is now called Sheldon's. In 1917 Mr Tomkinson's daughter, Ethel, was a Wesleyan Missionary in India when a new born baby was abandoned by the parents and left with her. Ethel brought the child, Monica Sumitri, back to Colwyn Bay to be looked after by her family. Monica, who as a child would have been a rare sight in Colwyn Bay in the 1920s, became a nurse, married and had six children.

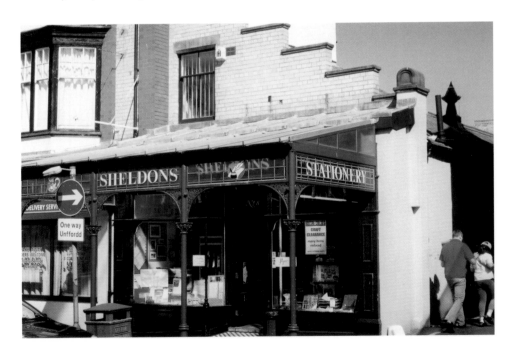

Ivy House

This was the first house in Colwyn Bay built in 1865 by Thomas Hughes on the corner of Ivy Street and Abergele Road. Mr Hughes opened a small grocer's shop in the building which grew into the most flourishing grocers in the district. Three businesses now use the site; a general store, a fire-place shop and a restaurant.

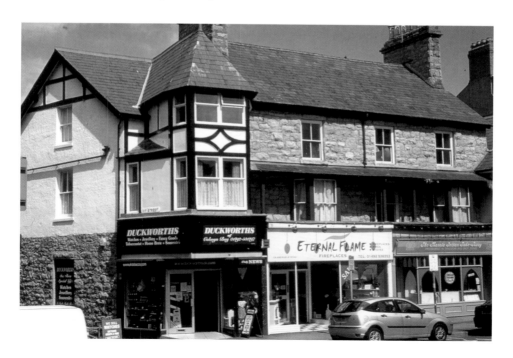

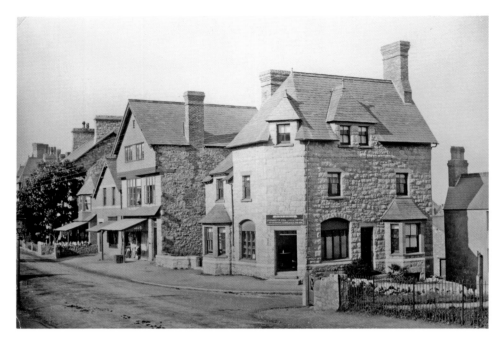

The Royal

This pub on Abergele Road, built in 1875, is named in honour of Queen Victoria. Colwyn Bay developed rapidly in the Victorian age; there is Victoria Park, the Victoria Pier, the Queens Hotel, the Victoria Club and the Victoria Jubilee Cottage Hospital. The old pub sign handing over the door way has been taken down and replaced by a graphically designed jumble of letters so bland as to render it unintelligible.

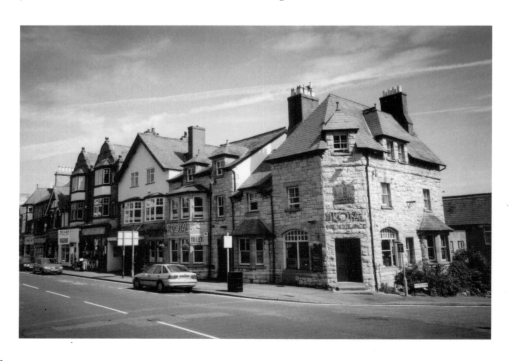

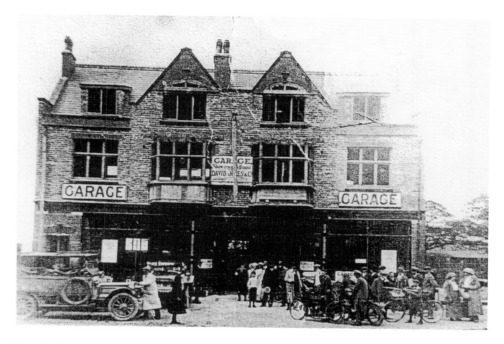

The Carlton Garage

The garage on Prince's Drive was run by Mr Broad and has long gone. For many years the indoor market was on the site and now there are tentative ideas about pulling the whole property down and revamping the area. This property faces up Penrhyn Road to the old Boots shop pictured on page 64.

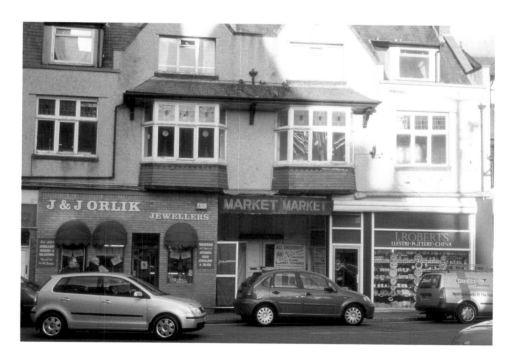

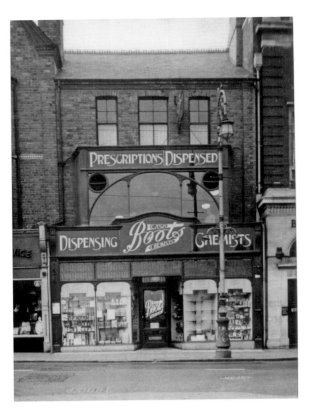

Boots the Chemist

The shop was in Kinmel House, on the left in the photograph below, facing Penrhyn Road. In 1914 this was one of a chain of 500 owned and run by Jesse Boot of Nottingham who advertised under the slogan 'Health for a Shilling'. On the first floor was a small lending library, the idea of Mrs Boot. It is now a shop selling mobile telephones and the present Boots store is in Station Road.

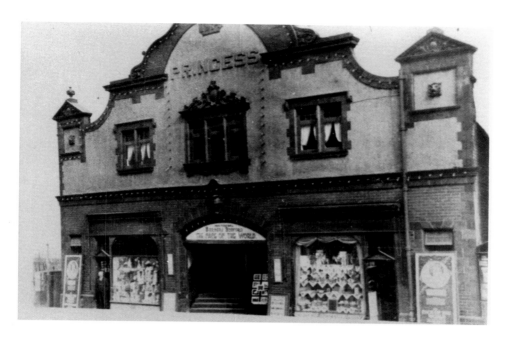

The Princess Cinema

This was a cinema from the time it was built in the 1920s to 1999 when it was converted into a Wetherspoon's pub. Immediately after the war there were six cinemas in the Colwyn Bay area; the Supreme in Old Colwyn, the Cosy on Abergele Road, the Princess and the Arcadia on Prince's Drive and the Rhos-on-Sea Playhouse. Now they are all gone and everyone goes to the multiplex in Llandudno Junction.

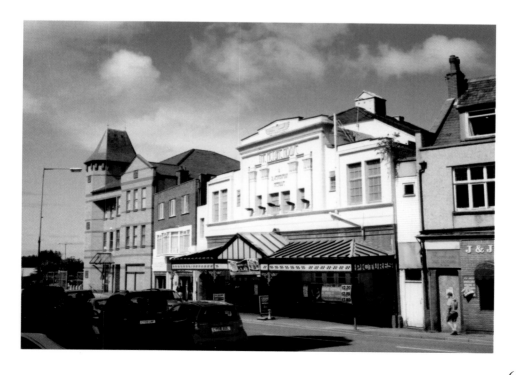

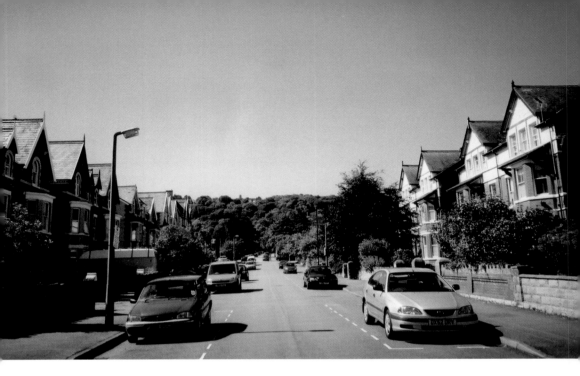

Mostyn Road

Looking towards the junction of Conway Road and Queen's Road with Queen's Lodge, Lord Colwyn's home, in the background in the picture above, and behind that, the Pwllycrochan Woods. This road is a perfect example of the Victorian expansion of the town. Large houses built for families from Lancashire and beyond, with accommodation for the maid, which between the wars became boarding houses and small hotels which in the latter part of the twentieth century became multiple flats.

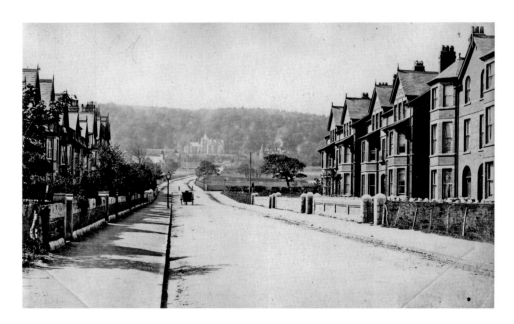

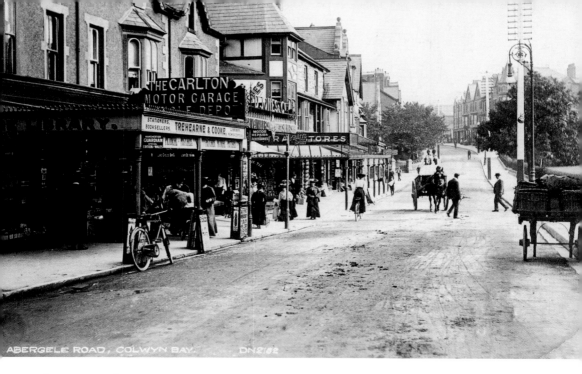

ABERGELE ROAD, COLWYN BAY. DN2/62

The Centre of Town

The Carlton Garage on the left (above) was demolished in the 1930s and replaced by a splendid building designed by Sydney Colwyn Foulkes known as Dando's shop, and is now called A & A Cash and Carry. Ivy Street is on the left and is the only thoroughfare in the town which is named as a Street. In 1910 there was a toll gate at this spot until one night it was mysteriously torn down and thrown into the sea.

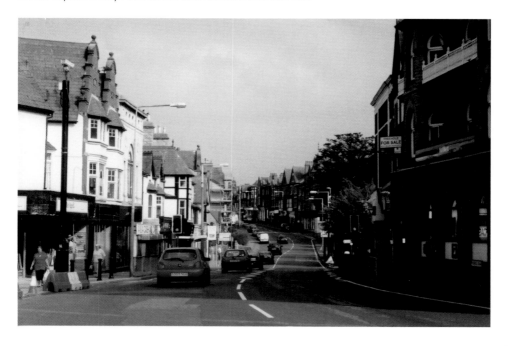

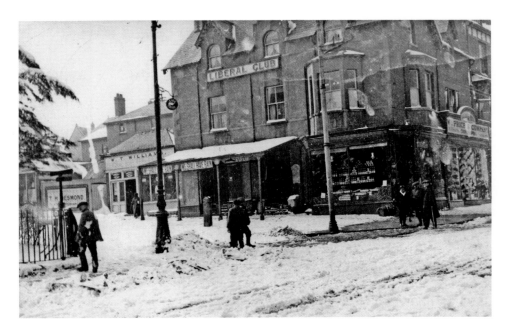

F. W. Woolworth & Co

The present building was erected in the late 1920s specifically to house the Woolworth's bazaar. It replaced the original, more interesting building, on the corner of Woodland Road East and Abergele Road. Although in the old photograph there is snow on the ground the sign beneath the shop canopy reads, 'We shall have rain'. Since the collapse of the Woolworth's business in 2009 the shop has remained empty.

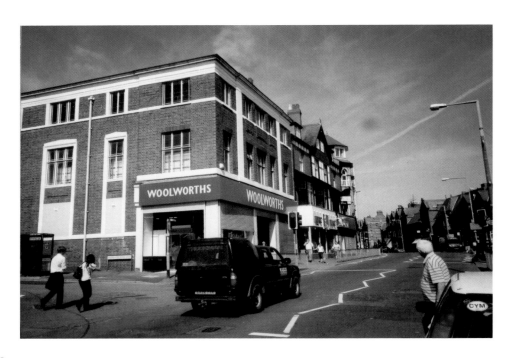

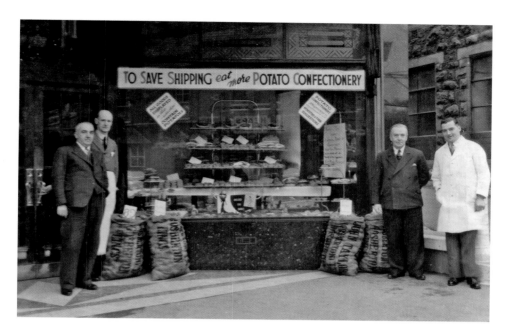

The Co-op: Sea View Road

The old building was demolished in 1996 to make way for the 30 Llys Trefor flats which were opened in 1998 by Mr Trefor Davies, known locally as Trefor Co-op, a man who raised thousands of pounds for the young peoples Urdd Eisteddford. In the old picture the store is promoting the eating of potatoes during the war. The sign reads: 'Potato Confectionary in accordance with Ministry of Food Instructions'.

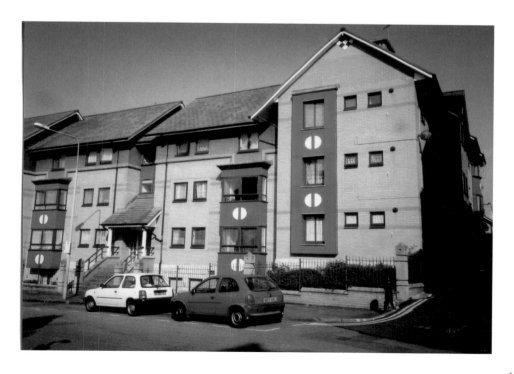

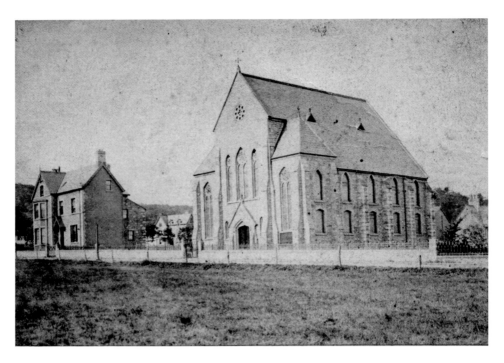

Engedi Welsh Presbyterian Chapel
The first chapel in Colwyn Bay, costing £700, was built in 1873 where Matthew's hardware store now is on Conway Road; it was used by both the Welsh and English congregations. The congregations split and in 1879 and the Welsh employed John Roberts to build Engedi Chapel on Woodland Road West. Sadly it is now derelict and awaiting redevelopment.

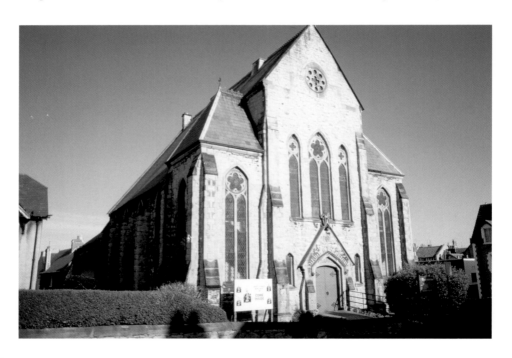

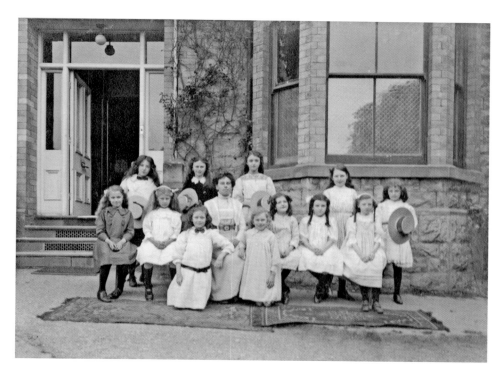

College School

This girls' school, on the corner of Grove Park and Abergele Road, was one of many small private Dame Schools, so called because they were run by spinster ladies of a certain age. It is now the Grosvenor Hotel. It was reputed to be a slightly batty school, where sometimes, for instance, they would teach nothing but algebra all day. In 1920 the school moved to a building, now demolished, on the promenade and admitted boys.

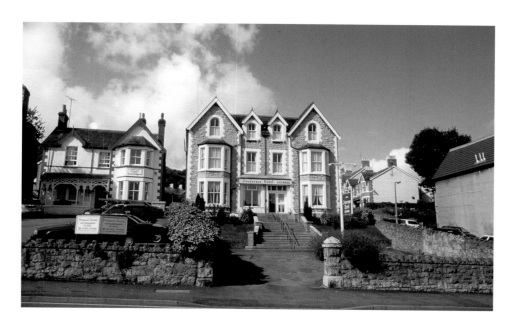

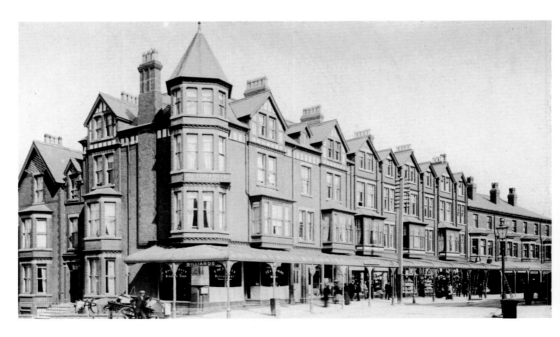

The Tram Terminus at Aston's Corner

After the tramway company had stopped their service as far as Old Colwyn this became the terminus. The tower on the left-hand corner (above) became unsafe and was demolished in the 1960s. The glass verandas have gone and the original shops have all been replaced by modern ones; for instance a computer shop and the excellent Cambrian Photography.

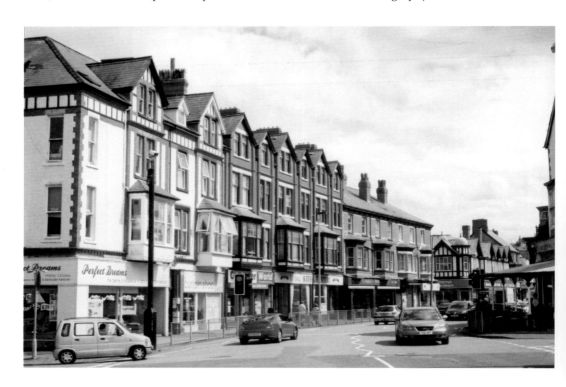

Jones Brothers

In 1900 the brothers were Henry and Samuel Wiggin Jones. Samuel is in the doorway of what is now 79 Abergele Road, where today the Curtain Shop is located. In the Jones' day the premises was called Marbury and next door to the left was the Temperance Hotel, which is now the Perfect Dreams bed furniture shop.

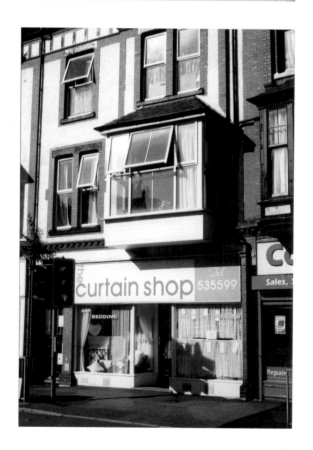

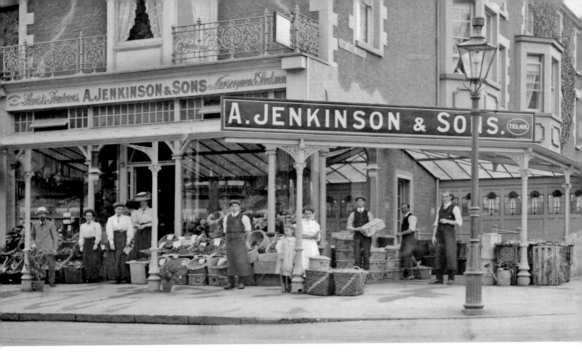

Elianus

This building on the corner of Abergele Road and Rhiw Bank Avenue was built *c.* 1899 by the son of the Point Lynus Lighthouse keeper on Anglesey. He named it thus because in the sixth century St Elian landed near Point Lynus and Elianus is the Latin version of that name. Jenkinson & Sons was a greengrocery business which closed in the 1970s and the shop is now used to sell antiques.

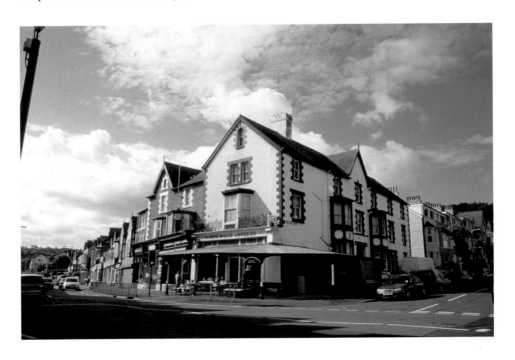

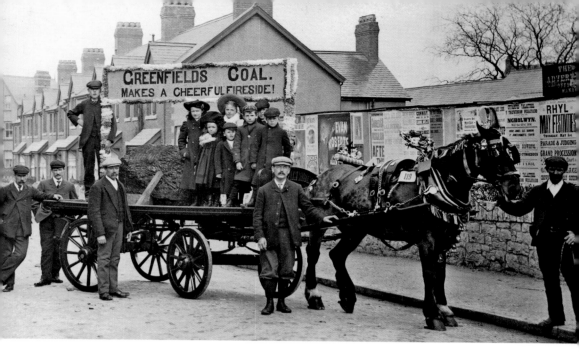

Erw Wen Road

The road is a cul-de-sac and consists of two terraces of well appointed homes, with the one exception of the Powlson's printing business on the left. On the right on the corner was Braid's Garage, the premises of which are now used by the Stermat general store. Within the time difference of the two pictures the road has been transformed from a peaceful side-road into a parking nightmare.

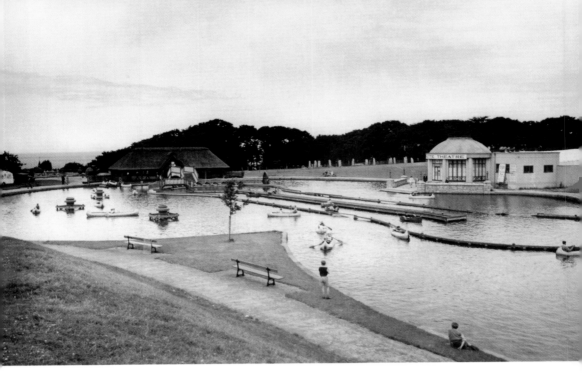

Eirias Park

This land which still forms a natural break between Colwyn Bay and Old Colwyn, was acquired by the council on 12 April 1924. It soon became a place of recreational amusement with a bowling green, tennis courts, boating pool, holiday golf course, puppet theatre, café, model boat pool and a Dinosaur World attraction. The café, sailing boat pool, puppets and dinosaurs are now gone but the area is still considered a holiday destination.

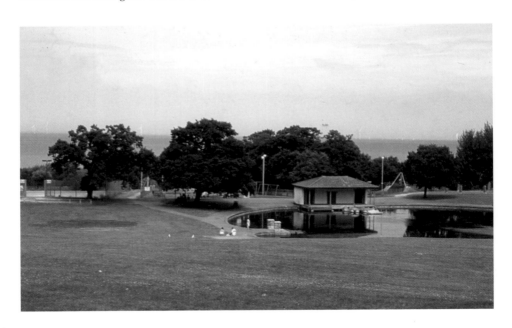

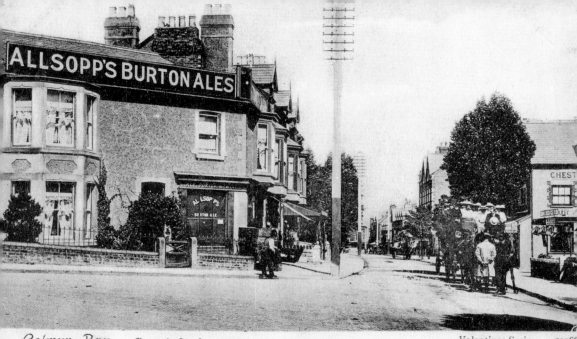

Colwyn Bay. *Abergele Road*

The Park Hotel

The old pub, on the left in the picture above, on the corner of Nant-y-Glyn Road, was pulled down in 1922 and replaced by the present Park Hotel which lacks all the character and warmth of the original. The buildings next to the pub were left standing and remain there today. The lamppost on the right of the old picture is one of the original forty-eight from 1883 when the gas company charged 30s per lamp.

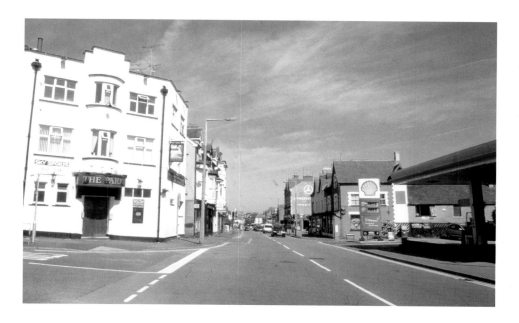

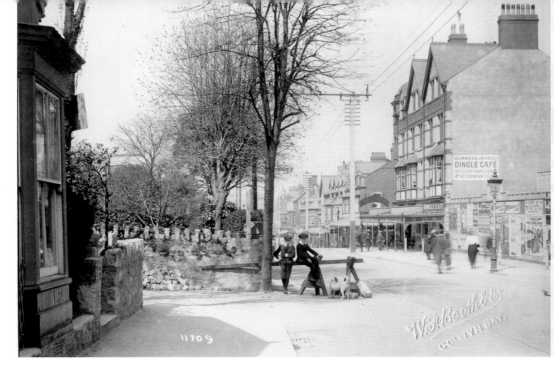

The Dingle

This area takes its name from the Dingle stream that runs down to the sea to the right of the pictures. The end wall of the building on the right has acted as an advertising hoarding for 90 years and the original veranda on the right is all that remains of the fine workmanship which once enveloped most of the shops of the town. The Close cul-de-sac of eighteen homes is off to the left.

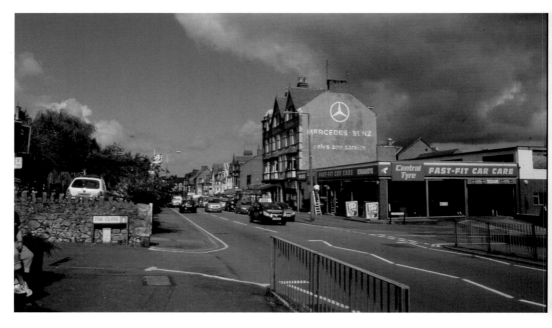

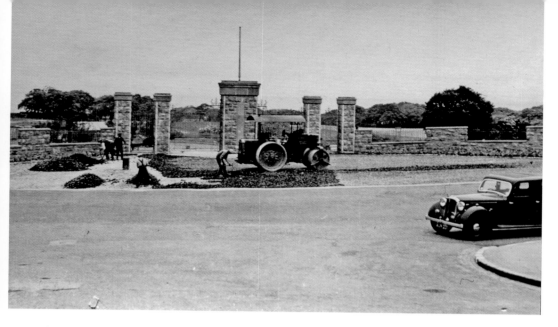

Eirias Park Entrance

This is the spot where Mr Greenfield had his second blacksmith's business. (See page 81 for his first workshop). When his workshop on this site was pulled down in the early 1930s the council used the stone to build the walls and pillars for the new entrance to the park. The gates were erected to commemorate the visit of the National Eisteddfod of Wales in August 1947.

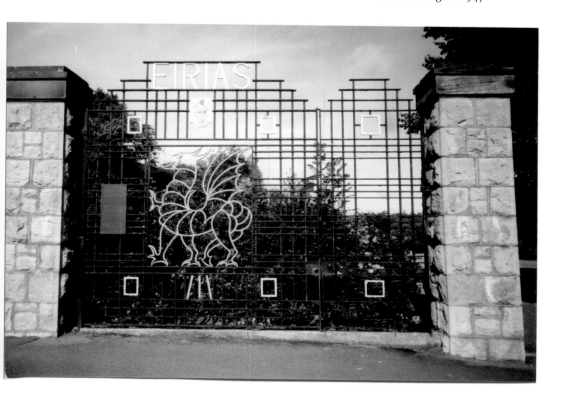

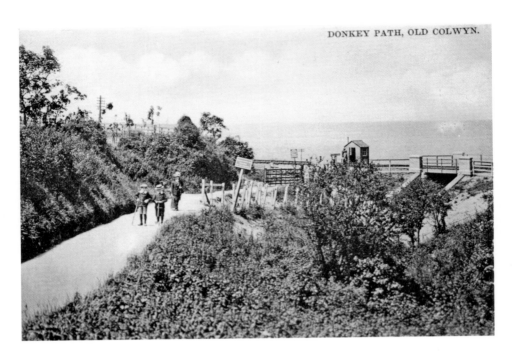

DONKEY PATH, OLD COLWYN.

The Donkey Path

In the 1870s a footpath used to run across the fields from the present Marine Pub roundabout down to the sea shore. In 1900 it was decided to improve the path so a black donkey was raffled and raised £60 for the work. At the time donkeys were also used to haul the seaweed from the shore for use as manure. When the A55 was built in 1983 the old path was in part destroyed but was reinvented as a concrete walkway on concrete stilts.

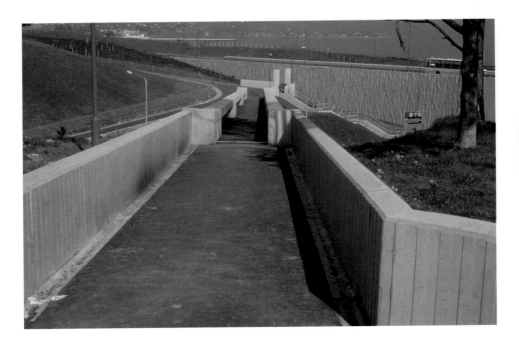

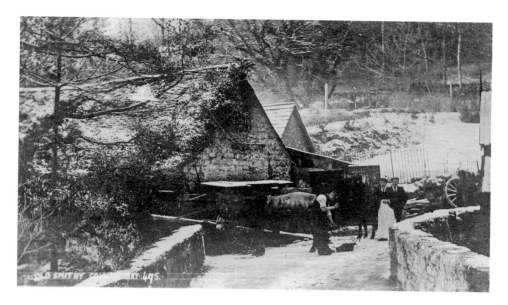

The Groes Smithy

In the 1890s this was Mr Greenfield's smithy beside the Groes River on The Old Highway (see page 79). In the picture below the young lady can be seen examining the remains of the smithy wall. There was another smithy at the other end of the highway in Mochdre (page 17). Mr Greenfield designed and constructed the wrought iron gates, which are still in place, for the Union Church in Colwyn Bay.

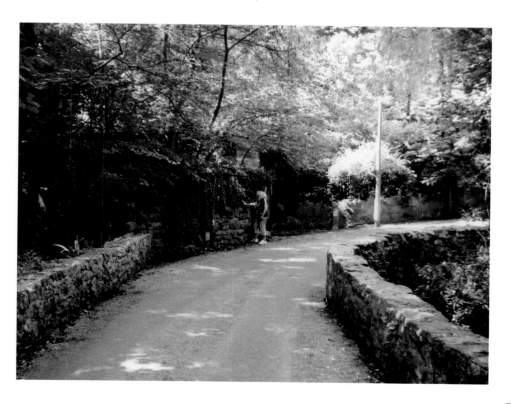

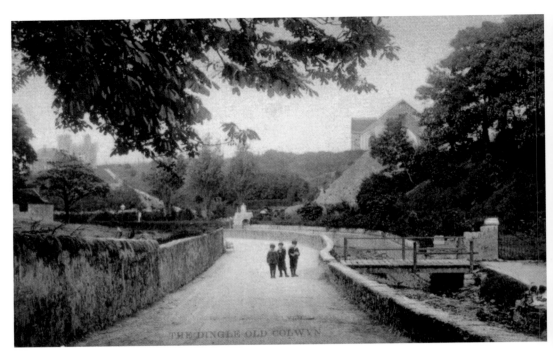

Beach Road

So named because it runs down to the beach. The river on the right is the River Colwyn which flows through Llawr Pentre (page 87) and the castle type building on the skyline is a folly. This was once upon a time part of the ancient route along this part of the coast, which is now lined on one side, with 1920s built semi-detached houses.

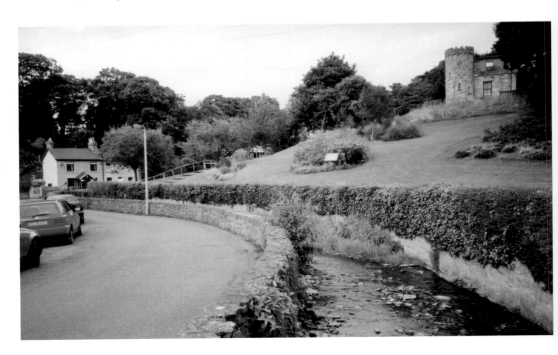

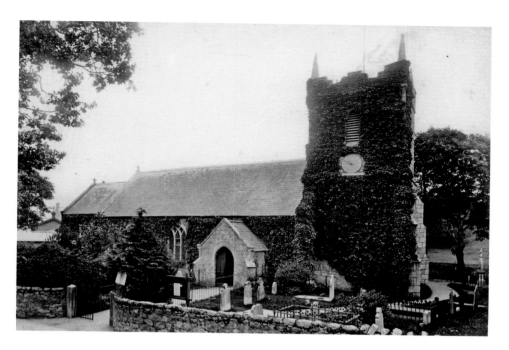

St Catherine's Church

The church was built in 1837 as a chapel of ease to Llandrillo and remained so until a parish was assigned to it in 1844. The land was given to the church by Mr John Lloyd Wynne of Coed Coch; the east window, dedicated to Richard Butler Clough, was given by his widow and the clock in the tower was installed in 1890 in memory of The Revd J. D. Jones, the vicar from 1866 to 1887. The vicarage, across the road, is now flats for the elderly.

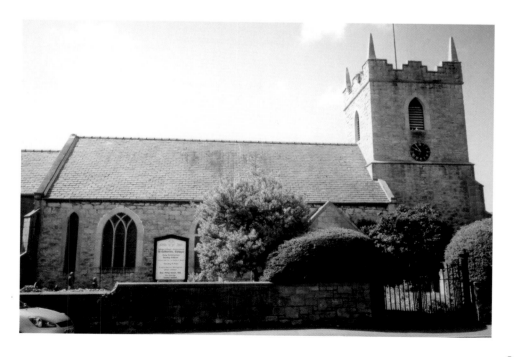

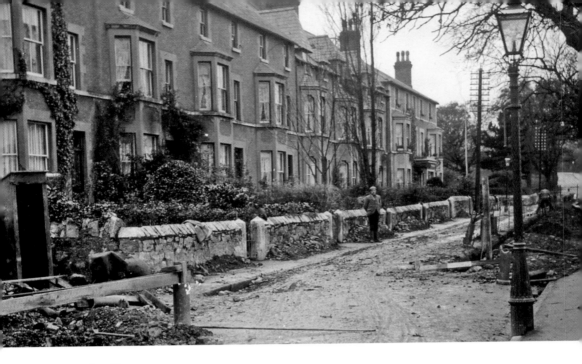

Marine Terrace

The Marine Hotel in the background, now beside a busy roundabout, and the terrace were some of the first buildings to be erected in the 1850s as Old Colwyn expanded. With one conversion to a shop, the rest of the terrace is still residential, but now on a very busy main road which funnels traffic to the police centre, two large schools and a new business park.

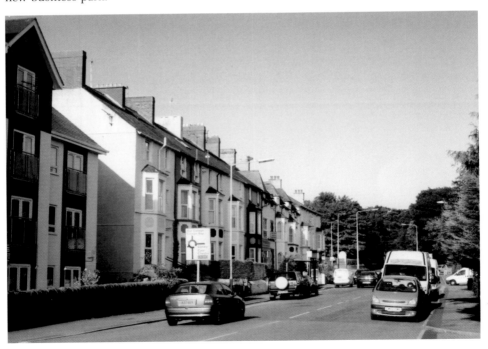

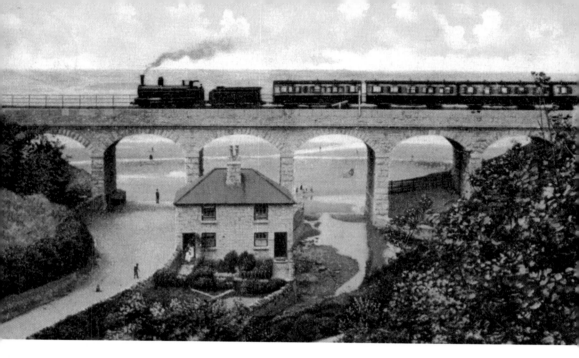

Crossing the River Colwyn

You can no longer see the river at this point as it is entirely covered in a tunnel. The railway bridge was built in 1850 and jumps the same span as does the A55 dual carriageway which was built in 1983. Beach Road is seen in the old photograph and the cottage was demolished to make way for the extension of Wynnstay Road down to the promenade.

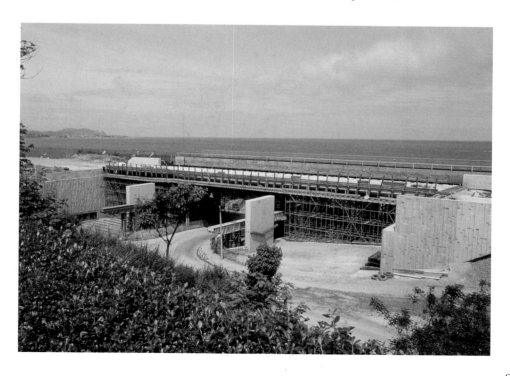

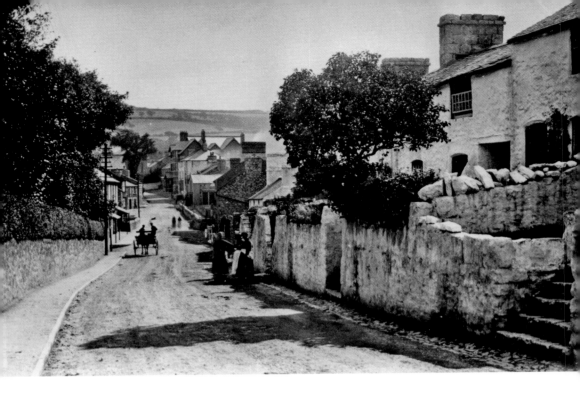

Plough Terrace

Both pictures show Abergele Road in Old Colwyn sloping down to the road bridge over the River Colwyn. The top picture shows Plough Terrace, on the right, in the late nineteenth century. It was demolished in the 1920s to make way for flowerbeds and a walkway up into Rose Hill.

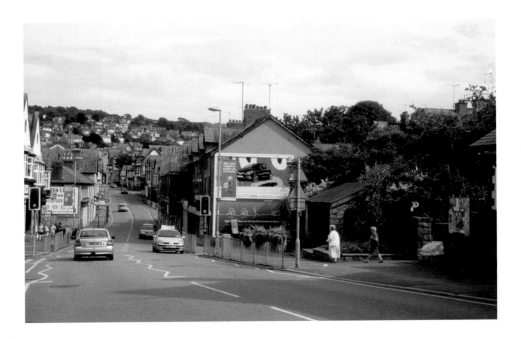

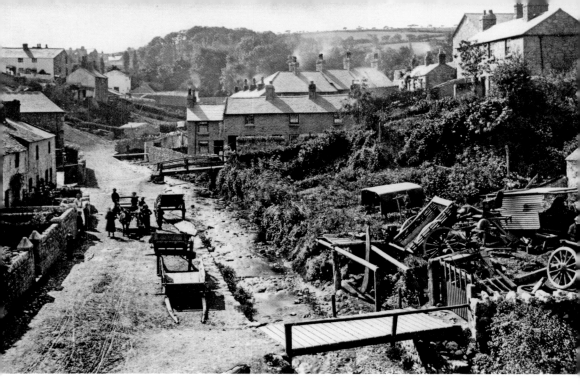

Llawr Pentre

The wheel-wrights on the right of the picture above had one of the busiest businesses in the area until the automobile arrived. Bleach was made here and the Liverpool firm of Alexander & Fowler, who made artificial limbs, had a subsidiary outpost here where you could go for fittings. Just off to the right, in Greenhill, was the two-roomed junior school built in 1868. It is now a purely residential area.

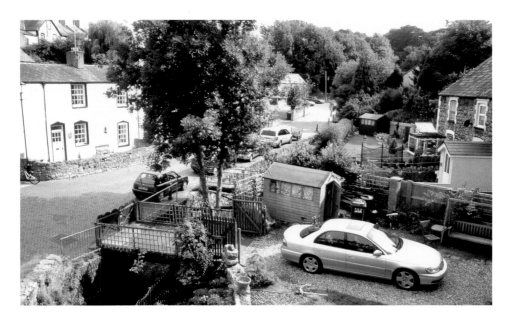

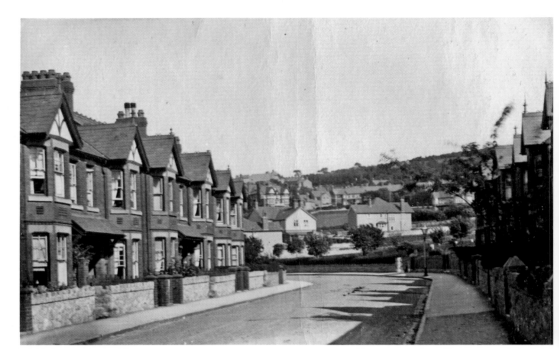

Cadwgan Road, Old Colwyn
This is a fine example of the substantial and interesting residential landscape left behind by the builders and architects of the early twentieth century, which is confident and comfortable. It was in this area that Cadwgan Farm (see page 93) was situated and since the picture above was taken the Old Colwyn Methodist Church has been built at the end of the road.

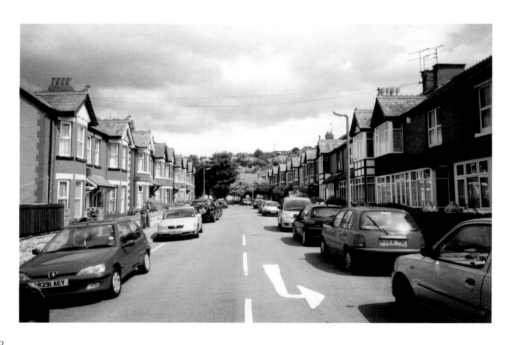

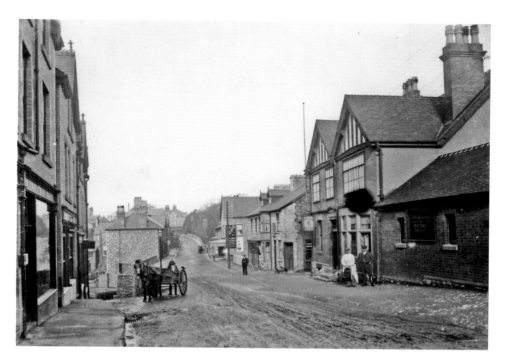

The 'New' Red Lion

The present Red Lion pub on the right is the end building of a line of shops built *c.* 1810 from which many of the old family businesses of Old Colwyn were run. These included William Owen fishmongers; Parr's Bank; Fred Price and Sons, family butchers of Tudno House, who when they closed the business for the last time in 1998 had been trading for eighty-eight years. Llawr Pentre (page 87) is down the little road on the left.

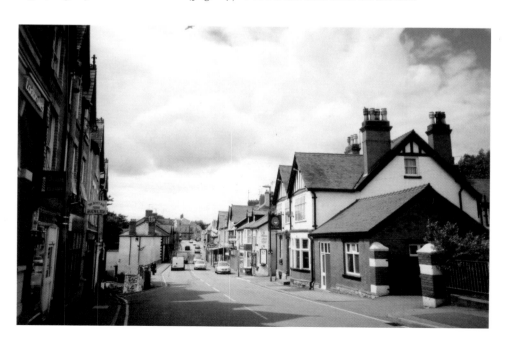

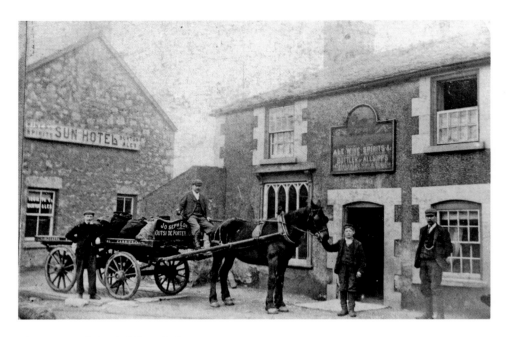

The Sun and the 'Old' Red Lion

The Sun Hotel on the left of the picture above is exactly the same building as stands there today. The present Red Lion (page 89) stands on the same site as the old demolished pub seen in the same picture. The owner of the cart standing by the window on the right was Joseph Edwards, a registered 'outside porter' to the Old Colwyn railway station. The man on the left was Mr Bennett, the owner of the Sun.

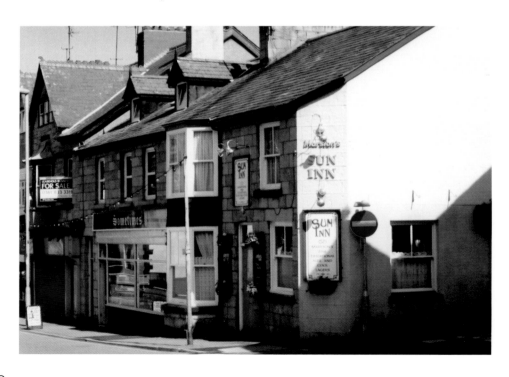

Miners Lane

This lane to the left of the present picture is so called because this was the route taken by the miners as they trudged down the cliffs of the Penmaen Head to the quarries on the sea front. In the 1920s, to widen the A547, two shops were demolished at the bottom of the lane which then made it possible to build Bethel Welsh Chapel. The architect, Sydney Colwyn Foulkes, designed a mural for an interior wall which was considered too racy by the chapel elders and had to be painted over.

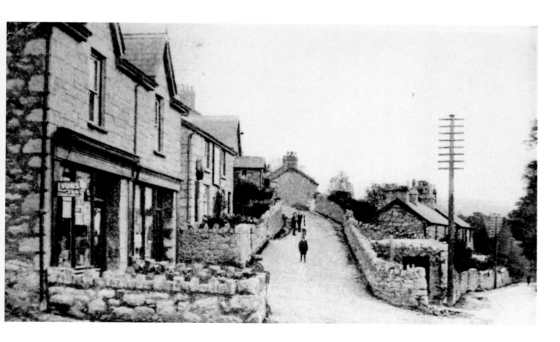

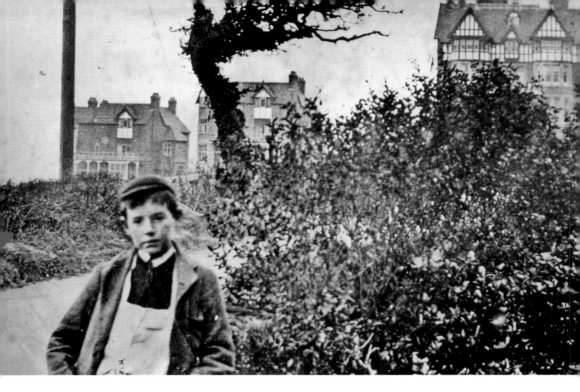

The Queen's Hotel

The hotel, on the right in the picture above, is a view looking up Abergele Road towards Penmaenhead. The picture below is a view of the building looking the other way down into Old Colwyn and Colwyn Bay. As with the other hotels in the town, the building was used by the Ministry of Food during Second World War. It is now a nursing home. The other two buildings in the old photograph are still there on Queen's Road.

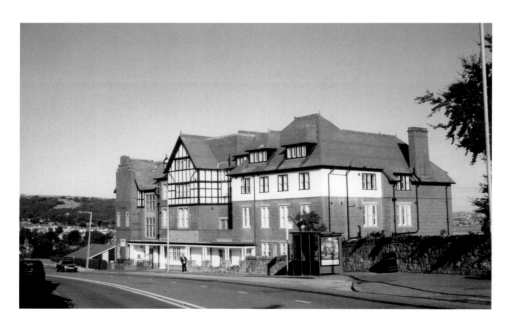

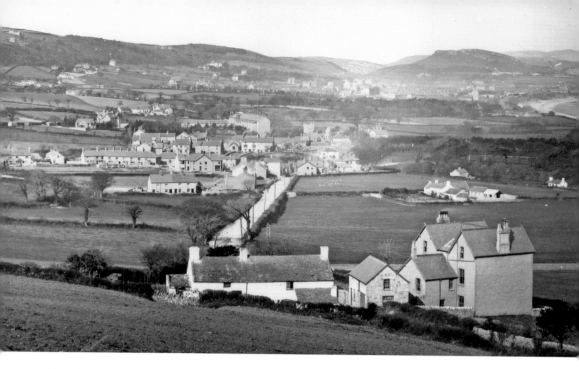

Old Colwyn Bay

The picture above shows the original Colwyn clustered in the centre and the new emerging town in the distance beside the arc of the sea shore. The building in the bottom right-hand corner is now the Lyndale Hotel, while the Cadwgan Farm in the fields to the right has now gone. St Catherine's church is in the centre and the obvious terrace to the left of the church is Marine Terrace (page 84). All the fields have now been built on.

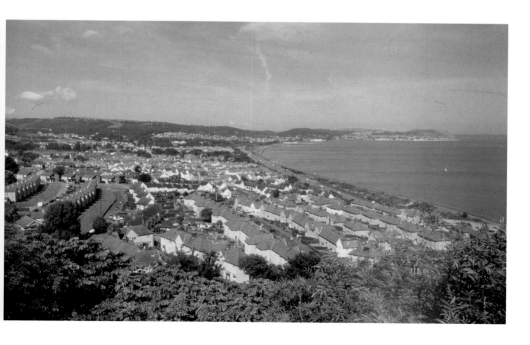

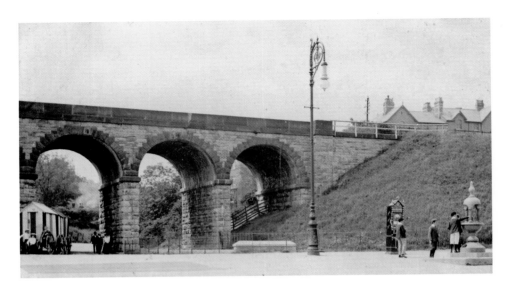

The Dingle Railway Bridge

The road under the bridge leads from the promenade to Eirias Park. This bridge and Colwyn Bay Railway station were built by Owen Gethin Jones and when he died in 1883 six hundred people followed his coffin to its last resting place. He was born in Penmachno in 1816, won several Bardic Chairs and built nine railway stations along the London & North Western Railway line. His most incredible feat was the construction of the railway viaduct in the Lledr Valley named Pont Gethin in his honour. Irish workers were brought in to construct the railway embankment and the bridge and they were housed in specially built homes on Sea View Road, all of which are now shops.

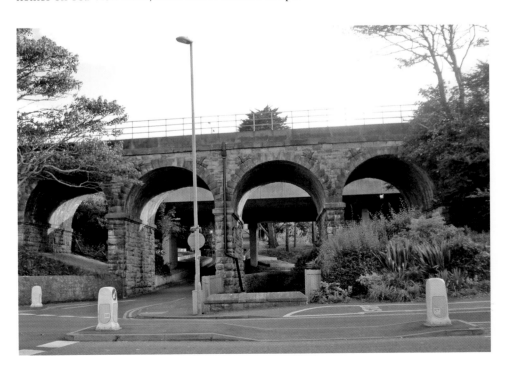

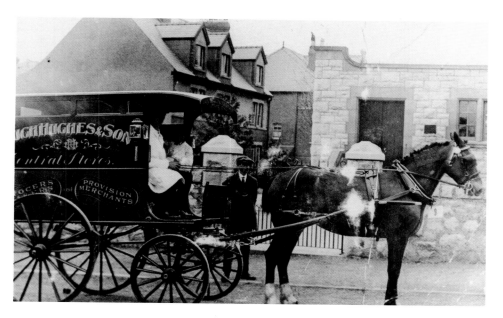

Colwyn Bay Infants' Council School

The school, behind the horse, in Douglas Road (top left hand corner in the picture below) was built in 1908. Douglas Road, a cul-de-sac off Abergele Road, has always been a hive of activity for children; the school is now the Colwyn Bay Youth Centre, and next door, what used to be the Friendship Youth Club run by Bill Hollywood, is now the Douglas Road Educational Centre. Across the road from the school was the Corona drink depot and Clegg's Monumental Masonry Works has been transformed into a car park.

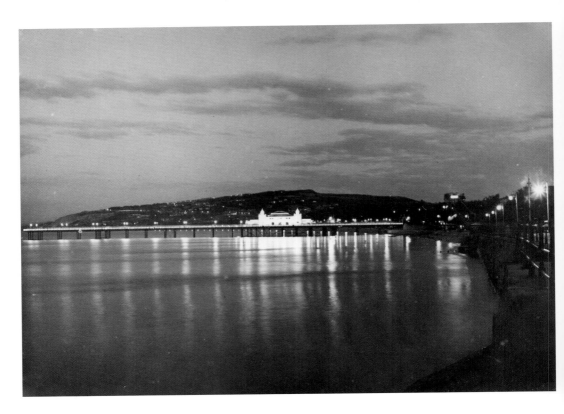

The Pier in the evening in the 1950s.

Acknowledgements

I am grateful to Susan Ellis, the senior archivist, and her staff at the Community Development Service, Llandudno, Eunice Roberts at Colwyn Bay Library, The National Library of Wales, Aberystwyth, and to Dennis Allen, Jill Davies, Peter Lawton, Bridget Tyers and Derek (Bryn Elian) Williams for the loan of photographs.